Calligraphy
in Ten Easy Lessons

Eleanor Winters
and Laurie E. Lico

DOVER PUBLICATIONS, INC.
Mineola, New York

Bibliographical Note

This Dover edition, first published in 2002, is an updated and
revised version of the work produced by the Miller Press, Inc. and
published as a Fireside Book by Simon & Schuster, Inc., New York, in
1986. The new and revised material was produced especially for this
edition.

Library of Congress Cataloging-in-Publication Data

Winters, Eleanor.
 Calligraphy in ten easy lessons / Eleanor Winters and Laurie E.
Lico.
 p. cm.
 Originally published: New York : Simon & Schuster, c.1984.
 Includes bibliographical references.
 ISBN 0-486-41804-9
 1. Calligraphy. 2. Writing, Italic. I. Lico Albanese, Laurie, 1959–
II. Title.
Z43 .W75 2001
745.6'1—dc21
 2001042342

Manufactured in the United States of America
Dover Publications, Inc., 31 East 2nd Street, Mineola, N.Y. 11501

CONTENTS

Introduction / 9
Assembling Your Materials / 11
Definition of Terms / 14

LESSON 1
Getting Ready and Making Basic Strokes 15

LESSON 2
The First Group—i, a, u, c 23

LESSON 3
The Second Group—l, d, b, h, n, m, r 33

LESSON 4
The Third Group—j, p, f, g, y, q 41

LESSON 5
The Fourth Group—o, e, k, s, t, v, w, x, z 49

LESSON 6
Spacing and Connections, Necklaces, Words
and Sentences 59

LESSON 7
Swash Capitals 67

LESSON 8
Numbers and Punctuation 83

LESSON 9
Changing Nibs, Writing in Color, Making
Corrections 91

LESSON 10
Using Your Skills 97

Questions and Answers / 107
Appendix / 109
Suggested Further Reading / 112

Introduction

Calligraphy is a craft that requires few tools, minimal financial investment, and no artistic training. It is an art form that anyone can learn. Whether you are a professional artist or an amateur, this book will provide you with a new mode of creative expression. You will learn an alternative writing method that is lovely, legible, and fun to use.

The word *calligraphy* comes from the Greek, meaning "beautiful writing." Calligraphic scripts used for writing books are called "bookhands." A "hand" is a specific style of calligraphy.

Before Johann Gutenberg invented movable type (circa 1450), books were written entirely by hand. Most of the books from the tenth to fourteenth centuries were written in the Gothic hand (also called black letter), characterized by compressed, angular, ornamental letters, which are slow to write and difficult to read.

With the Renaissance came a revival of education and a renewed interest in book production. Scholars needed a more rapid, legible, bookhand. They found their model in the Carolingian manuscripts of the ninth century, which evolved into the Humanist bookhand. A rapid, slanted form of the Humanist bookhand was adopted by the chancery office of the church, and was used for recording all papal briefs. It was called the "Chancery Cursive," or Italic hand. This style, which flourished in Italy in the fifteenth century, is the model for this book.

Italic was used and taught by the great writing masters of the Italian Renaissance. *The First Writing Book,* by Ludovico degli Arrighi, and *Three Classics of Italian Calligraphy,* which contains facsimiles of work from the masters Arrighi, Palatino, and Taglienti, are valuable sources for models of the Italic hand as it was first written.

When you are learning calligraphy you must learn to see it as well as write it. By studying strong, beautiful, and historically accurate examples, you will recognize fine calligraphy and have a goal for which to strive. At the end of your lessons you will be ready to practice copying the work of the Renaissance scribes or of contemporary masters. An appendix at the end of this book lists many sources for both old and new references.

The beauty of Italic is in the variation of its thick and thin strokes and the repetition of certain basic forms. As you progress through the following lessons you will see sequences of letters that are built around each basic stroke and form. This structural uniformity gives Italic its integrity and strength.

"Ten Easy Lessons" does not mean that calligraphy is easy—it means that the lessons in this book are simple and progressive. This is the only book to break the learning process down into ten basic steps, with simple building blocks for easy reference.

Mastering any art requires practice, patience, and perseverance. This can make the difference between mediocrity and excellence. Good luck, and have fun!

Assembling Your Materials

The physical requirements for calligraphy are a few simple tools and a well-lit, quiet place to work. Have the following tools assembled before you begin:

Pen:

We suggest that you buy the Mitchell/Rexel* Roundhand Square package, containing ten assorted pen points (nibs) and two slip-on reservoirs. Some packages also include a penholder. It is available in some art supply stores or can be mail-ordered (see "Sources" in the Appendix).

The ten nibs in the package graduate in size from $1/32$ of an inch (No. 6) to a little over $1/6$ of an inch (No. 0). You will be using the No. $1\frac{1}{2}$ nib throughout these lessons, which will exactly match the size of the instructional examples. This comparatively large nib will produce lower-case letters that are approximately a half-inch high—large enough to judge the shape and quality of the letters accurately, and to magnify errors so that you can detect and correct them right away. By the end of the lessons you will be able to broaden your range of writing sizes and use the other nibs in your Rexel package.

If you are left-handed, you may want to use the Rexel Left Oblique Pen, which has a special edge that makes it easier to write left-handed.

The Rexel nib is excellent for both the beginner and the professional; its sharp edge produces crisp lines, and it is slightly flexible so that you will learn to monitor pen pressure—a very important skill.

*"Mitchell/Rexel" will hereafter be referred to as "Rexel" in this manual. See Appendix for additional information on calligraphy materials, including other nibs, inks, rulers, etc.

Paper:

You will need a pad or package of graph paper, 8½" × 11", with eight boxes per inch. You will also need a pad of white bond paper, 11" x 14". Hammermill Bond (or Aquabee 666), Canson Pro-Layout Marker, Borden & Riley Cotton Comp, and Bienfang Graphics 360 are all good quality papers that are highly recommended. *Do not* use special calligraphy paper or parchment, as it is often absorbent and of inferior quality. Test your paper before beginning. If it is too absorbent or too rough, don't use it. If it is too slick or slippery (such as glossy paper), your pen will slide as you try to write.

Ink:

Any nonwaterproof black ink will be fine. Higgins Eternal black ink is recommended. *Do not* use waterproof ink—it contains shellac which will damage your nib.

Pencil:

Use a 3H or 4H pencil to draw lines on your paper. The number and letter of the pencil indicate that it is medium-hard lead, which produces fine, thin lines that erase easily but will not smear.

Ruler:

A fifteen-inch metal ruler is needed for drawing lines on the paper. A metal ruler is much better than a wooden one because it sits flatter on the page, which enables you to draw more accurate lines.

Attach a strip of masking tape to the back of the ruler to keep it from sliding on the paper.

Slanted Writing Surface:

You must always be able to see what your hand is doing, and therefore must have enough room on the writing surface to move the paper up and down and from side to side with ease. The slant of your surface is optional. Most calligraphers like to write on a slanted surface, although others prefer to work flat. Choose whatever is most comfortable for you.

The surface should be slightly padded, which may be achieved by placing a pad of paper under the page you are working on (you will be removing each sheet from the pad before you begin working on it).

A TIP

You can construct a handy drawing board quite simply with a piece of firm cardboard, 14" x 17", and approximately eight sheets of the same size bond paper. Use masking tape to secure the edge of the paper to all four edges of the cardboard.

Light:

Light should be good but not glaring. It is most important that your light does not cast the shadow of your hand across the writing surface. If you use an adjustable reading lamp, you may shine it down directly in front of you, or you may place it to your left if you are right-handed and to the right if you are left-handed.

Soft Cloth and Water Container:

These should be nearby at all times for easy rinsing and drying of your pen as you work.

Clothes:

Ink spills! Consider this when you select your garments and also when you set up your work space. Wear clothes that you are not worried about ruining.

A TIP

Secure your ink to the table with a folded piece of masking tape underneath the bottle to safeguard against spillage.

Definition of Terms

Acquaint yourself with the following calligraphic terminology before you begin Lesson 1.

Ascender: the portion of the lower-case letters b, d, f, h, k, and l that extends above the waist line.

Base line: the writing line.

Broad-edged pen: a nib with a flat, square-cut edge, used for the Italic hand.

Counter: the white space inside the letters. Also known as "white space" or "negative space."

Descender: the portion of the lower-case letters f, g, j, p, q, and y that extends below the base line.

Hairline: the finest line you can make with your pen.

Ligatures: the strokes that connect letters. Also known as "joins."

Majuscule: a capital letter.

Minuscule: a lower-case letter.

Nib: the pen point.

Pen angle: the angle at which the edge of the nib is held to the base line. In Italic, the pen angle is *always* 45°.

Swash: a decorative stroke.

Waist line: the line that defines the upper limit of the body of the small minuscule letters. The letters a, c, e, i, m, n, o, r, s u, v, w, and z fit precisely between the base line and the waist line.

X-height: the height of the small minuscule letters (those without ascenders or descenders). This is determined by the width of the nib.

LESSON 1 | *Getting Ready and Making Basic Strokes*

Setting Up Your Materials

When you have assembled all your tools—pen, ink, paper, pencil, ruler, soft cloth, and water container—you are ready to set up your work space. This should consist of a well-lit writing table in a quiet place where you will be undisturbed. Preferably this will become your calligraphic corner, where you may safely keep your work-in-progress spread out at your convenience. A permanent work area that is always set up will make your practice sessions easier and more effective.

Posture

Posture is very important in calligraphy. Your chair should be at a comfortable height, so that both feet touch the floor and your forearms rest on the table. You must be able to look directly at your work from a straight perspective. When you are sitting balanced in your chair, your arm will move freely and you will be able to see your work from the proper angle. Balance is very important when you are working; if you are sitting on one foot, or leaning on one arm, it will be more difficult to control the pen and see your letters properly. The position for calligraphy is the same as that used for typing.

You must always be able to see what you are writing. Your paper should not be anchored to anything and you must have enough room to move it comfortably as you work. Detach each sheet of paper from your pad before you begin working on it. Hold the paper with your free hand to keep it from sliding. Adjust the paper position as needed.

If you are right-handed your paper should be slanted slightly uphill to the right.

Left-handed calligraphers generally write with their papers tipped in the opposite direction (downhill to the right), so that their hand moves downhill from left to right.

Setting Up the Page

For Lesson 1 you will be using graph paper with pencil-drawn lines at half-inch intervals. On eight-boxes-to-the-inch graph paper these lines will be four boxes apart. Using your 3H or 4H pencil and metal ruler, draw lines on your graph paper now.

If you are working with Brause nibs, your line-ruling system will be a little different. Please see the Appendix for further instructions.

For every line of writing you will need four lines to enclose three half-inch spaces. In order, from top to bottom, these are the ascender line, the waist line, the base line, and the descender line. The spaces are the ascender space, the x-height space, and the descender space. Although you will not be using the ascender or descender spaces until Lesson 2, it is important to familiarize yourself with the proper page setup from the very beginning.

Sample Page

ascender line →

 ascender space {

waist line →

 x-height space {

base line →

 descender space {

descender line →

asc. sp.

x-ht. sp.

des. sp.

asc. sp.

etc.

Protecting the Writing Surface

Keep a sheet of paper between your hand and the writing surface, to keep the page clean and prevent the oils in your hand from being absorbed by the paper. If you do not protect your writing surface, you may find your pen skipping as you reach the bottom of the paper.

Assembling the Pen

The Rexel pen package contains a small, triangular, gold-colored metal piece called a reservoir. This clips into position on the nib, with the inward curve facing the nib, and the triangular tip of the reservoir approximately one-eighth of an inch below the tip of the nib. The point of the reservoir should just barely touch the nib. Do not be afraid to bend the reservoir into the correct position, or to bend the side clips so that it stays securely attached to the nib.

To attach the No. 1 1/2 nib to the plastic pen holder, slip the nib securely between the prongs and the outside plastic edge of the holder.

Keeping the Nib Clean

Ink tends to build up on the nib. As you work, occasionally dip your pen into water and then wipe it dry with the soft cloth. Do this every five or ten minutes to keep the nib clean and the ink flowing.

When you are finished working, remove the nib from the pen holder, rinse it in water, and wipe it dry. Never store the pen with the nib attached, and never leave the pen lying around with ink in the reservoir. Whenever you stop working, even if it's only for a few minutes, be sure to rinse and dry the nib.

A TIP

Use your soft cloth to grasp the nib when putting it in or taking it out of the pen holder. This protects your fingers from the nib and vice versa.

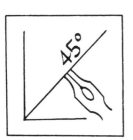

Building Block 1

The proper pen grip is very important for good performance. The pen should be held in the same way an ordinary pen or pencil is held, and should meet the paper at the same direction as your pen or pencil does. *The nib of the pen must always meet the writing line at a constant 45° angle.*

Hold the pen toward the end of the pen holder. Your fingers should be just above the nib, but not touching it. The greatest degree of control is in the thumb and the forefinger.

Keep the pen relaxed in your hand; do not squeeze too tight or press too hard. If you are not relaxed, you may find that your hand gets tired (from squeezing too hard) or that the nib is splitting and you are getting too much ink on the paper (from pressing too hard). You will find that your writing is more graceful when you hold the pen comfortably and correctly.

Dipping the Pen into Ink

Shake the ink bottle a little each time before opening. Dip the nib into the ink approximately a half-inch—covering almost the entire nib. Wipe both the front and back of the nib once against the edge of the ink bottle to remove excess ink.

After you dip the pen into the ink, make a few zigzag marks on a piece of paper to be sure that the ink is flowing properly. When your thin line (the upstroke) is as thin as the diagram in Exercise 1, then you are ready to begin.

A TIP

Keep a sheet of scrap paper next to your ink bottle. This will remind you to make the test strokes before beginning to work.

This exercise is designed to teach you the 45° relationship between the edge of the nib and the base line.

1. Begin by placing the edge of your nib on the base line, at a 45° angle. (Building Block 1)
2. Move the pen upward to the waist line in a diagonal direction from bottom left to upper right. Your line should intersect the corners of all four boxes on the graph paper as it passes through them. If made correctly, this is the thinnest line your pen can make; it is a hairline.
3. At the waist line (without lifting your pen or changing the 45° angle), move the pen diagonally downward, from left to right, to the base line. Again, intersect the corners of all four boxes as your pen passes through them. If made correctly, this is the thickest line your pen can make.
4. You have drawn one complete zigzag. Practice a few lines of zigzags until all the upstrokes are thin and all the downstrokes are thick.

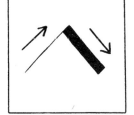

Building Block 2

Make your strokes slowly, stopping at the end of each zigzag and lifting your pen off the paper. At this point you are developing a relationship between your hand and the pen, learning exactly how much pressure must be applied to achieve a perfect stroke.

Accuracy Check

1. If you are pressing too lightly, your lines may be shaky. If you are pressing unevenly on the nib (both corners of the nib are not making complete contact with the page), one edge of your thick line will be fuzzy, as shown in the examples that follow. Be sure that the entire nib is pressing evenly and completely on the paper and that the ink is flowing smoothly.
2. The two lines (the upstroke and downstroke) should form a 90° angle to each other.

A TIP

This exercise is a good way to check your pen angle. During your first few sessions, always begin by practicing the zigzag stroke until you are sure that your pen is at a 45° angle to the base line.

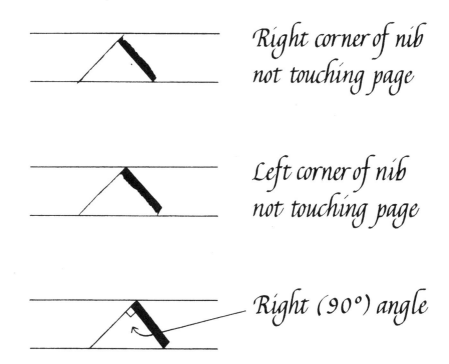

Right corner of nib not touching page

Left corner of nib not touching page

Right (90°) angle

Exercise 2: The Vertical Downstroke

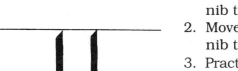

1. Place your pen on the paper with the right-hand corner of the nib touching the waist line.
2. Move the pen straight down, until the left-hand corner of the nib touches the base line.
3. Practice this until each stroke consistently resembles the examples at left.

Accuracy Check

1. If you are holding your pen at a 45° angle, the top and bottom edges of the stroke are also on a 45° angle.
2. If your strokes resemble (A) or (B), then you are not holding the pen at a 45° angle. If they resemble (C) or (D), then you have uneven pressure on the nib. To correct these errors, practice the zigzag lines until you master the pen angle and pressure.

A B

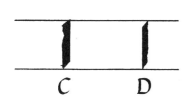

C D

1. Place your pen on the paper with the right-hand corner of the nib touching the waist line.
2. Move the pen in a straight line from left to right, across the length of two boxes.
3. Practice this until each stroke consistently resembles the example below.

Accuracy Check

1. If you are holding your pen at a 45° angle, the beginning and ending edges of the stroke are also on a 45° angle.
2. If your strokes resemble (A) or (B), then you are not holding the pen at a 45° angle. If they resemble (C) or (D), then you have uneven pressure on the nib. To correct these errors, practice the zigzag lines until you master the pen angle and pressure.

A TIP

When made correctly, the vertical and horizontal lines are the same width. You can test this by drawing a cross, which will show any error in the width of your strokes.

Note: Letters begin with a top-to-bottom or left-to-right movement whenever possible because the ink flows most smoothly when you write in these directions. This is why some letters will require an overlapping stroke.

A B

C D

LESSON 2 | *The First Group ~*
i, a, u, c

In this lesson you will begin learning to make the individual letters of the Italic minuscule alphabet. A clear understanding of the following principles is crucial to your mastery of the hand.

X-height

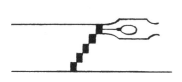

The x-height is the distance between the base line and the waist line. In Italic the x-height is always equal to five times the width of the pen nib. To determine this distance, make five nib marks, stacked corner to corner, on top of each other. Measure the distance from top to bottom: The x-height varies proportionately with the size of the nib. Using the No. 1½ nib, the x-height will always equal one-half inch.

Drawing Margins and Lines

You are ready to make the switch from graph paper to plain white paper. This means that you must measure and draw margins and lines.

Margins should be between 1″ and 1½″, with the bottom margin slightly larger. An easy way to draw margins is to place your metal ruler at the edges of the paper and simply trace around it (rulers are usually 1″ or 1½″ wide).

Using the metal ruler and a well-sharpened 3H pencil, mark off one-half-inch lines along both the left and right edges of the paper. Connect the dots horizontally to draw your lines.

A TIP

If you are using relatively thin paper, you can use a fine-point magic marker to make a master guide sheet for lines and margins. Clip or loosely tape the guide sheet beneath the page you are working on, thus eliminating the need to draw lines for each new page.

Speed, Rhythm, and Accuracy

Work slowly. You are learning the formal Italic hand, which is distinctly different from an informal Italic script. The formal hand requires that you lift your pen off the paper after each letter.

Try to develop a steady rhythm as you work. After you learn and perfect all the letters, you may wish to refer to other books for instructions on joining letters with a minimum number of lifts to form a more rapid Italic script. As you practice, make your letters slowly and carefully, with the greatest attention to consistency and accuracy of form.

Always refer to the examples given in the text, rather than copying your own previous practice letters. Using your own work for reference results in repetition, rather than correction, of your errors.

Advice for Lefties

You may find it difficult to control the pen and maintain the 45° angle. This will be easier if you slant your paper downhill to the right, which enables you to write with your pen below the base line (rather than overhand, as you may be accustomed to writing). It will take some practice to find the paper slant that works best for you, but do not be discouraged. Left-hand students learn to overcome obstacles by improvising the sequence of some strokes, or sometimes by making a stroke counterclockwise rather than clockwise. You will find this happening instinctively as you progress and improve. Remember that practice and patience are your allies, and that some of the world's most renowned calligraphers are left-handed.

24

One of the most important features of the Italic alphabet is the slant of the letters. Italic letters are always slanted between five to ten degrees to the right. For the purposes of your lessons, all letters will be either exactly on the 7° slant, or evenly bisected by the 7° axis.

When it is useful, instructions for making a letter are accompanied by a diagram showing the relationship between the letter and the 7° angle. A good way to check this angle is to imagine a 7° parallelogram superimposed over a letter, as in the illustration below.

7° parallelogram

Do not confuse the 7° slant of the line with the 45° pen angle. The relationship between the nib and the base line must always remain at a constant 45°.

This is the simplest letter of the Italic hand, formed with a 7° downstroke that begins and ends with a hairline stroke and uses a third hairline to form the dot.

1. As a preparatory exercise to acquaint yourself with the basic movement of the pen and the shape of the letter, do the following:
 Take the vertical line that you learned in Lesson 1, and tip it 7° to the right, as shown in the illustration.
2. Beginning just below the waist line, make an upward hairline stroke from left to right, to the waist line. Then make a 7° downstroke from the waist line to the base line. Touch the base line and end with a short hairline upstroke to the right.
3. To make the letter "i," both hairline strokes must be rounded at the point where they meet the downstroke. By slightly rounding the top and bottom of the form in step 2, you will be making the body of the letter "i."
4. The dot over the "i" is positioned in the center of the ascender space, on the same 7° axis as the body of the letter. It is a hairline upstroke.

Accuracy Check

1. The "i" should be on the 7° angle.

The "a" Shape

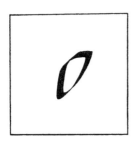

Building Block 3

This is a very important basic form which is used repeatedly throughout the Italic alphabet.

1. Begin by placing the pen with the right corner of the nib touching the waist line. Make a small stroke from left to right, followed immediately by an overlapping stroke from right to left. This is the top of the "a" shape, which sits just below the waist line.
2. Without lifting the pen off the paper, swing the stroke downward to the left, at the same 7° slant as the letter "i." The curve at the top of the stroke should resemble a twisted ribbon, with a narrow point where the downstroke begins.
3. After touching the base line, curve the stroke up to the right, meeting the original stroke at the right corner to close the shape. This curve is a very important stroke that you will find repeated throughout the Italic hand. Practice the curve by itself until it feels comfortable.

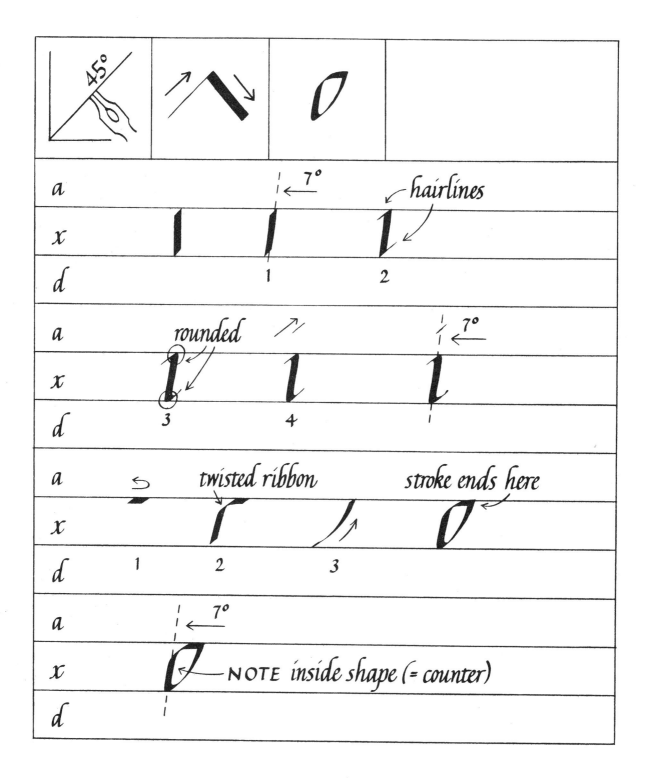

a	← 7° hairlines
x	
d	1 2
a	rounded ← 7°
x	
d	3 4
a	twisted ribbon stroke ends here
x	
d	1 2 3
a	← 7°
x	NOTE inside shape (= counter)
d	

Note: The "a" shape is the basis of the letter "a" as well as the letters c, d, g, u, y, and q. Be sure that you understand and are familiar with the inside space (the counter), and the outside of this shape, because it is crucial to your mastery of Italic.

Accuracy Check

1. The top left corner should resemble a twisted ribbon; it should not be pointed.
2. Observe the counter in the illustration. Your counter should be the same shape and width.

The Letter "a"

When you have mastered the "a" shape, the steps to complete the letter are very simple.

1. Make a complete "a" shape.
2. At the waist line, without lifting the pen off the paper, make a 7° downstroke to the base line. This is exactly like the "i" shape, complete with the hairline endstroke.

Accuracy Check

1. *Branching* refers to the point of separation between the right curve of the "a" shape and the downstroke (the "i" stroke). The branching point for the letter "a" should be at approximately the center of the x-height space. If the branching point is too high, as in (A), or too low, as in (B), then your "i" stroke is not on the 7° slant; or the right curve of the "a" shape is too sharp, as in (C), or too round, as in (D).
2. Below the branching point the two strokes should form a triangular shape.
3. The letter "a" should fit inside the 7° parallelogram.

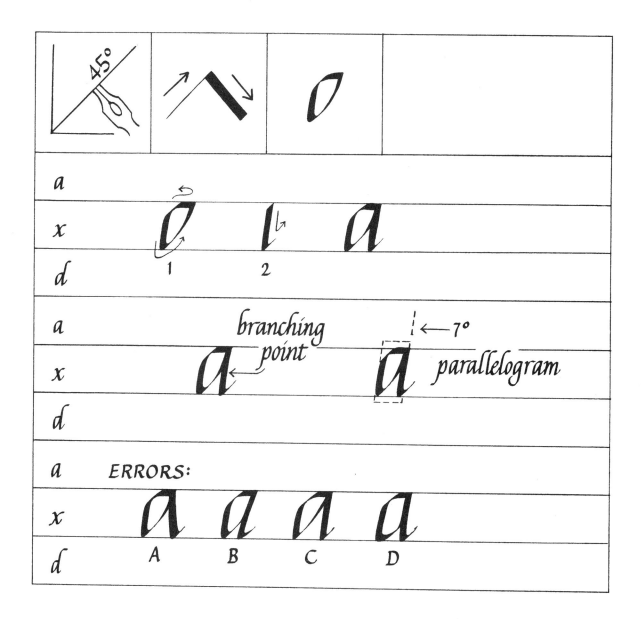

Note: If you are making your "a" shape correctly and if you have mastered the 7° slant of the "i" stroke, then your letter "a" will be correct. Practice making the letter until it is consistently correct.

The Letter "u"

The "u" is an open-topped "a." When you can make the "a" shape and the "i," the "u" is easy.

1. Begin with a hairline lead-in stroke followed by a downstroke to the base line. You should recognize this as the beginning of the letter "i."
2. At the base line, bring your upstroke to the waist line, in the same curve as the right side of the "a" shape.
3. From the waist line, bring the stroke to the base line, exactly like the downstroke of the letter "a." End with a hairline upstroke.

Accuracy Check

1. You should be able to superimpose the letter "a" right over the "u." This means that the branching points and counters of the "u" should be identical to those of the "a."
2. The right and left sides of the "u" should be parallel on the 7° slant. The "u" should fit precisely inside the parallelogram.

The Letter "c"

The letter "c" is an "a" shape, with the right side open and a slightly shorter (or narrower) stroke at the top.

1. Begin with a flat line at the waist line, made with a left-right/right-left stroke exactly like the first strokes of the "a" shape.
2. Follow into the twisted-ribbon curve and downstroke exactly like those in the "a."
3. At the base line, curve the pen up and out to the right in a hairline, at a slightly wider angle than the "a." End the upstroke just below the center of the x-height space.

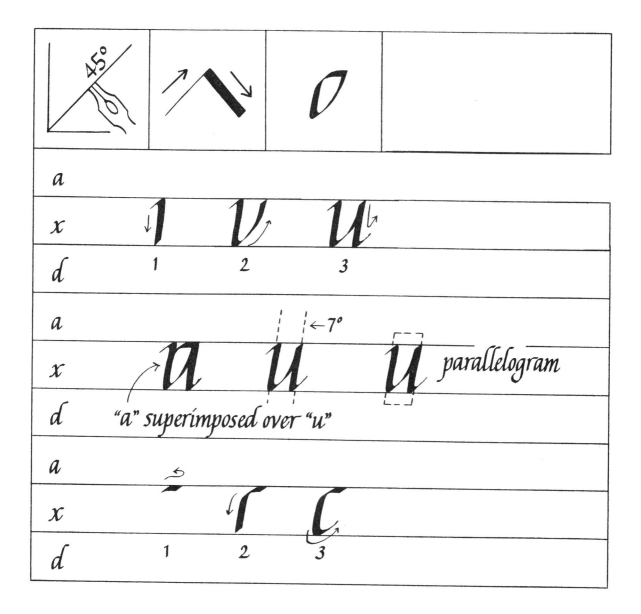

a			
x	1	2	3
d			
a			←7°
x			parallelogram
d	"a" superimposed over "u"		
a			
x	1	2	3
d			

The Second Group – l, d, b, h, n, m, r

The ascender is the portion of a minuscule letter that extends above the body of the letter, and above the waist line. The area between the waist line and the ascender line is the ascender space.

The height of the ascender equals the x-height. Thus, the distance from the base line to the ascender line equals ten nib widths. For your purposes (using the No. 1½ nib), the full length from the base line to the ascender line should measure one inch. Minuscule letters with ascenders are twice the height of those without ascenders.

The Letter "l"

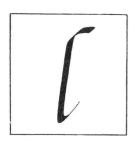

Building Block 4

This strong, slightly diagonal downstroke is also the basic ascender used for all other ascender letters.

1. Begin just below the ascender line with a flat left-right/right-left stroke, similar to the first stroke of the "a."
2. Turning downward with the twisted-ribbon effect, make a 7° downstroke to the base line.
3. End with an upstroke to the right, exactly the same length and angle as the endstroke of the "i."

Accuracy Check

1. If you neglect to make the twisted ribbon on the first downward curve, your turn will be too pointed, as in (A).
2. If you do not maintain the 45° pen angle on the downstroke, it will be too thin, as in (B).
3. If you curve the downstroke before reaching the base line, your letter will be too curved, as in (C).
4. The downstroke of the "l" should be on the 7° angle.

This is a combination of the "a" shape and the "l," made in two strokes.

1. Make a complete "a" shape.
2. Make a complete "l," which meets the "a" shape halfway into the x-height space.

Accuracy Check

1. The branching point between the ascender and the body of the letter is very important. If the ascender is too close to the "a" shape, the letter will branch too low, as in (A). If the ascender is too far away, the letter will branch too high, as in (B). If the ascender is too curved, it will also branch too high, as in (C).
2. If you cover the ascender, you should see a perfect letter "a."

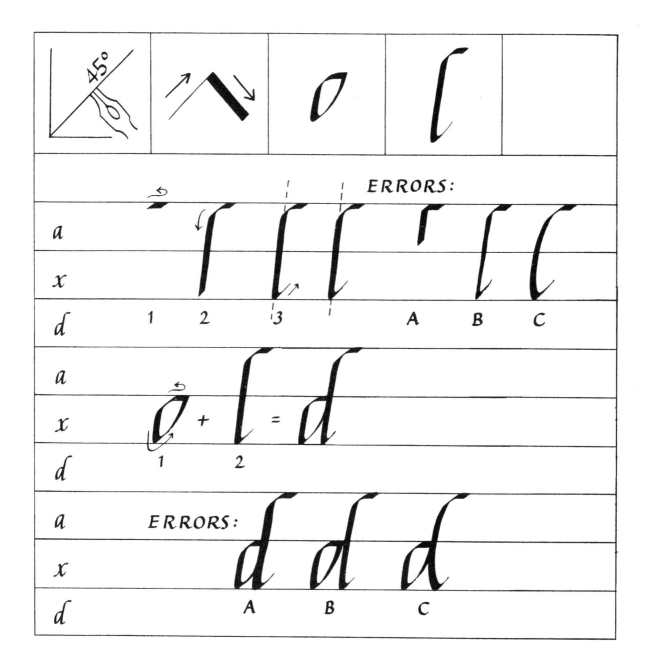

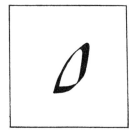

Building Block 5

1. The "b" shape is an upside-down "a" shape. It consists of the same strokes, made in the opposite direction.

1. Begin from the base line with an upward curve to the right, to the waist line.
2. From the waist line make a 7° downstroke, curving to the left just before it reaches the base line.
3. End the stroke flat across the base line, meeting the first stroke at the left-hand corner.

Accuracy Check

1. If you turn your page upside down, you should see the "a" shape, with the same counter.
2. The upper-right corner of the "b" shape should be curved; it should not be pointed, as in (A).
3. The downstroke on the right should be on the 7° axis; it should not be straight down, as in (B), nor should it curve to the right, as in (C).

A TIP

Practice alternating the "b" shape with the "a" shape, comparing strokes, shapes, and counters. Turn your page upside down occasionally.

The Letter "b"

This is a combination of the "b" shape and the "l," made without lifting the pen.

1. Make the "l" shape, minus the ending upstroke.
2. Without lifting the pen from the page, slide back up the downstroke, to the middle of the x-height space. Branch to the right to form the curve.
3. Complete the "b" shape, ending at the lower left-hand corner.

Accuracy Check

1. The right side of the "b" shape should be parallel to the left side; both should be on the 7° axis.
2. Check your "b" shape by turning the page upside down to see an accurate "a" shape.
3. Make sure that your branching point is in the middle of the x-height space.

The Letter "h"

This is simply an open-bottomed "b," with an endstroke.

1. Make the ascender (the "l"), minus the ending upstroke.
2. Slide back up the downstroke, to the middle of the x-height space, and branch to the right.
3. Bring your stroke down to the base line, and end with an upstroke to the right.

Accuracy Check

1. The ascender and the right side of the "h" should be parallel on the 7° axis.
2. Superimpose the "h" over the "b."

A TIP

Practice writing the "b" and "h" in alternating sequence, comparing strokes and branching points.

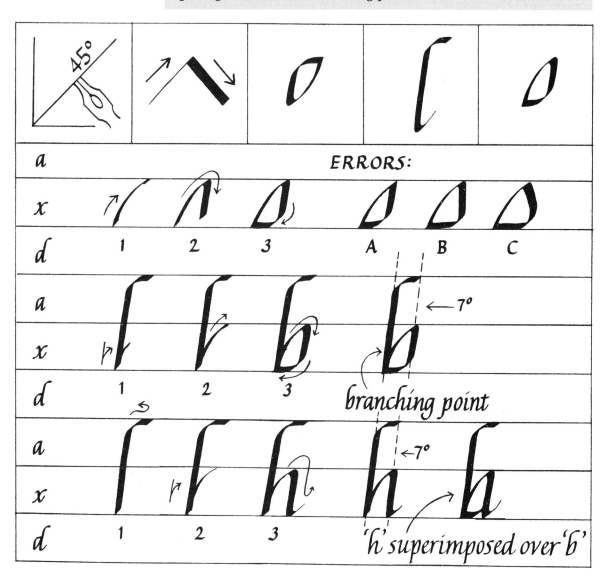

The Letter "n"

The "n" is the bottom half of the letter "h."

1. Begin with the "i" shape.
2. Slide back up the downstroke to the middle of the x-height space, branching out to the right, down to the base line, and back up in an endstroke, exactly as you would for the letter "h."

Accuracy Check

1. If you turn your page upside down, you should see the letter "u," with both sides of the letter parallel on the 7° axis.

The Letter "m"

This consists of two slightly compressed "n"s, made in one stroke.

1. Make the letter "n," touching the base line on the second downstroke and then sliding back up the line to the middle of the x-height space.
2. Branch to the right to form another "n" shape; this arch has exactly the same width as the first arch. End the "m" with an endstroke from the base line.

Accuracy Check

1. All three lines of the "m" should be parallel on the 7° axis.
2. The counter of both arches should be equal; each should be slightly smaller than the counter of an "n." If the arches are as wide as the "n"s, then the letter will be too wide, as in (A).
3. The space between the top of the arches should be triangular, formed by a branching point halfway into the x-height space. If branching is too high, your letter will resemble (B).

The Letter "r"

This letter is made like the "n," without the second downstroke.

1. Begin just below the waist line and continue in a 7° downstroke to the base line.

2. Slide back up the downstroke to the center of the x-height space and branch out to the right.
3. Extend this stroke flat under the waist line, ending with a very short stroke.

Accuracy Check

1. If the endstroke is too long, as in (A), it will mar the spacing between letters.
2. If the endstroke is too curved, as in (B), it is incorrect.

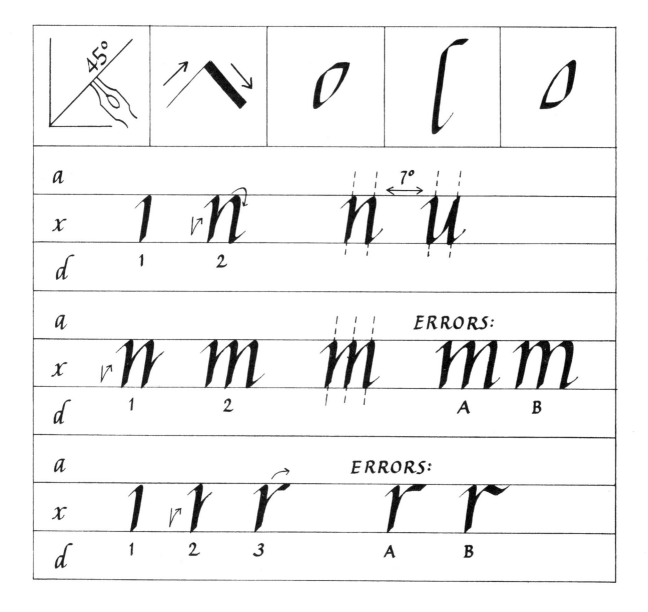

Now that you have completed this second group of minuscule letters you should begin to see the consistency of the alphabet. Notice that the letters h, b, n, m, and r all contain arches that unify them as a group.

Exercise 1

Alternate practicing overhand arches, as in the "m" and "n," and underhand arches, as in the "u."

Exercise 2

Practice writing the word *minimum*. You may connect the letters with slightly elongated endstrokes that are extended just enough to touch the next letter, but you must lift the pen off the page between each letter.

Remember that the counters of the "u" and the "n" are equal, the arches opposite, and the tops and bottoms of the letters should form similar triangular shapes in relationship to the waist line and the base line. Due to the similarity of the "m," "u," and "n," you may find that the word *minimum* looks like a series of overhand and underhand arches distinguished by the dots of the "i"s.

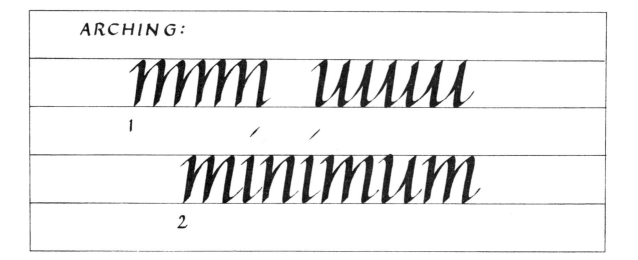

ARCHING:

1

2

The Third Group ~
j, p, f, g, y, q

This group consists of the descender letters. The descender is the portion of a minuscule letter that extends below the body of the letter, and below the base line. The area between the base line and the descender line is the descender space.

The length of the descender equals the x-height. Thus, the distance from the base line to the descender line equals ten nib widths. For your purposes (using the No. 1½ nib), the full length from the base line to the descender line will measure one inch.

There are two basic descender shapes: the simple descender and the teardrop descender. The simple descender is used in the letters "j," "f," and "p." The teardrop descender is more elaborate and is therefore more difficult to make. It is used in the letters "g" and "y." The descender of the "q" is a different form.

The Letter "j"

This letter, made with one stroke plus a dot, uses the simple descender.

1. Begin by making an "i" which extends (on the 7° axis) two-thirds of the way into the descender space.
2. Curve the stroke to the left with the twisted-ribbon effect, ending with a short, flat stroke along the descender line. *Do not* make an ending upstroke.
3. Dot the "j" in the same position as the "i": in the center of the ascender space and on the 7° axis.

Accuracy Check

1. If you turn the page upside down, you should see an "l."
2. The bottom curve should have the twisted-ribbon effect. If your "j" resembles (A), you have turned your stroke too late. If it resembles (B), you have turned your stroke too soon.

The Letter "p"

This is a combination of the "j" stroke and the "b" shape, made in two strokes.

1. Make the "j" shape (without the dot).
2. Begin at the base line and make the complete "b" shape. It should meet and branch away from the descender in the center of the x-height space.

Accuracy Check

1. If you turn the page upside down, you should see a perfect "d."
2. The first stroke and the "b" shape should branch at the center of the x-height space. If they are too far away from each other, they will branch too low, as in (A); if they are too close, they will branch too high, as in (B). The correct branching point will form a triangular space at the waist line.
3. The right and left sides of the "p" should be parallel, on the 7° axis.
4. If your "p" is incorrect, practice the "b" shape and the "j."

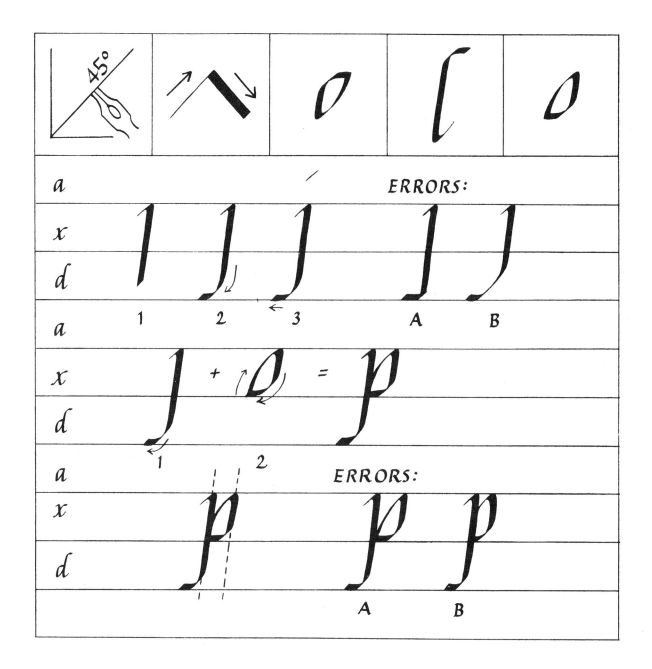

This is the longest letter of the alphabet, made with both an ascender and descender stroke. It requires good control of the pen.

1. Make an elongated "l," continuing the downstroke two-thirds of the way into the descender space (on the 7° axis).
2. Begin curving the stroke downward to the left, with the twisted ribbon at the turning point. Continue to the descender line, ending with a flat stroke across to the left.
3. Cross the "f" with a short left-to-right stroke that sits just below the waist line. The crossbar should extend further on the right than on the left.

Accuracy Check

1. It is easy to lose the 45° pen angle on this very long downstroke. If the bottom of the descender is narrower than the top, as in (A); or if the entire stroke is too thin, as in (B); or too thick, as in (C); you probably turned your pen and lost the 45° angle.
2. The "f" should not be slanted too far to the left, as in (D): it should be completely on the 7° axis.

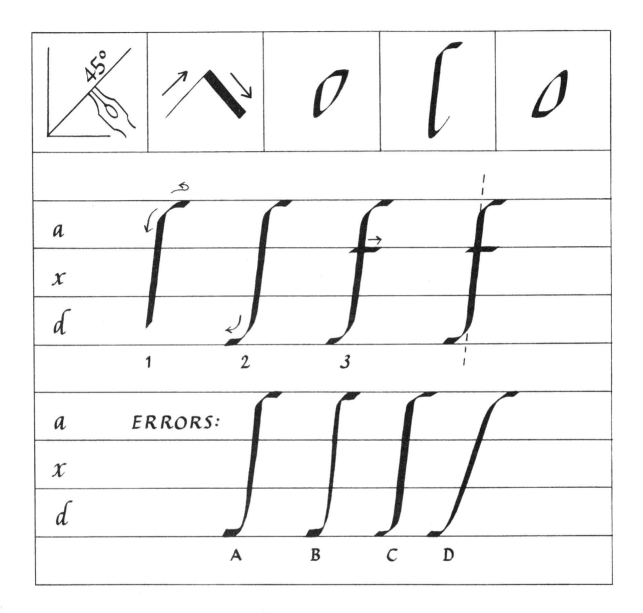

ERRORS:

A B C D

The Letter "g"

This letter introduces the teardrop descender, used only in the "g" and the "y."

1. Make the "a" shape.
2. Without lifting the pen, continue the downstroke below the base line, two-thirds of the way into the descender space.
3. Turn the stroke to the left with the twisted-ribbon effect, then curve across and wide to the left. Continue curving as you turn the stroke (*not* the pen) up to the right, defining the teardrop shape. End the stroke with a hairline that stops just before it meets the bottom left tip of the "a" shape. Do not close the curve completely.

Accuracy Check

1. The bottom right side of the descender stroke should not be pointed, as in (A); it should have the twisted-ribbon effect.
2. The left curve of the descender should extend wider to the left than the top "a" shape. If the descender is too narrow, as in (B), swing the bottom curve of the descender wider to the left.
3. The final hairline stroke should not turn in too sharply to the right, as in (C). This will distort the teardrop shape of the counter.

The Letter "y"

This is a combination of the letter "u" and the teardrop descender, made in one stroke.

1. Make the letter "u," and continue the downstroke into the teardrop descender.

Accuracy Check

1. The top counter of the "y" is the same as the counter of the "u," and the descender counter is exactly the same as the counter of the descender of the "g."

The Letter "q"

This introduces a new descender shape, which is attached to the letter "a" in one continuous stroke, to make the "q."

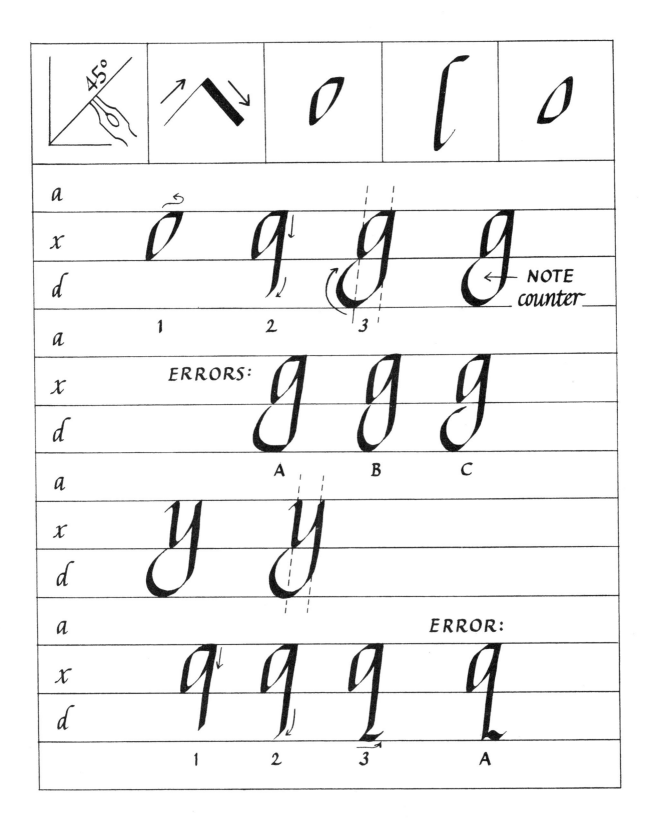

NOTE counter

ERRORS:

ERROR:

47

1. Make the letter "a," continuing into the descender space almost to the descender line.
2. Just before reaching the descender line, curve the stroke very slightly to the left.
3. Move your pen from left to right, making a short, flat stroke along the descender line. End with a very short hairline upstroke.

Accuracy Check

1. If the bottom of your descender resembles (A), you have wiggled the endstroke in the middle, instead of curving it to the left and bringing it straight across to the right.

The Fourth Group ~
o, e, k, s, t, v, w, x, z

The Letter "o"

This is an oval on the 7° axis, made in one continuous counterclockwise stroke. The top and bottom are exactly the same, as are the right and left sides.

1. Begin just below the waist line with a hairline stroke that widens as you bring the pen down to the left in a slight curve.
2. Touch the base line and curve up to the right with a hairline stroke that widens as it approaches the waist line.
3. Continue the stroke around, meeting the first stroke with a hairline to close the letter.

Accuracy Check

1. The "o" should look exactly the same if you turn your page upside down.
2. The counter is oval, with the same area (but not the same shape) as the "a."
3. If you begin on the waist line instead of below it, your letter will be too large, as in (A), or will have a flat top, as in (B).

A TIP

If your paper resists the upward motion of the pen, the "o" may be made in two downstrokes.

The Letter "e"

1. Begin just below the waist line, curving down to the left. Touch the base line and end with a hairline up to the right. This first stroke is made the same way and on the same curve as the beginning of the "o."
2. Place the pen back at the starting point. Curve it up to the waist line and around to the right, to just above the middle of the x-height space. Make a stroke to the left, meeting the inner curve exactly in the center of the x-height space.

Accuracy Check

1. A common error is to make this letter too round to the left and too wide to the right, as in (A).
2. The final inside line should be almost straight; if it is too diagonal it will meet the inside curve too low, as in (B).
3. Check the 7° axis of the letter. There is a tendency to tip the "e" too much to the left, as in (C).

The Letter "k"

Made in one stroke, this letter requires careful attention to the subtleties of the curves.

1. Begin with an ascender stroke to the base line.
2. Without lifting the pen off the page, overlap back up the ascender to the middle of the x-height space, and branch out to the right. Bring this stroke around in a small clockwise loop that meets the ascender line at the original branching point.
3. Now bring the stroke out to the right and downward with a small curve. Meet the base line and end with a hairline upstroke.

Accuracy Check

1. The counter of the bottom portion of the "k" should be almost triangular; it should not be square, as in (A).
2. The final downstroke should not be on a 45° angle, as in (B). This makes the letter too wide and will interfere with spacing when you are writing words.
3. The counter of the loop of the "k" is similar to the loop of the "e."

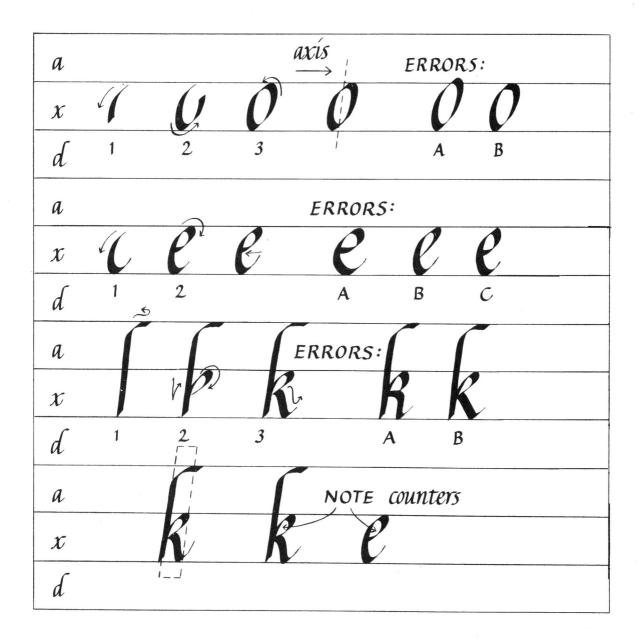

The Letter "s"

This consists of a straight diagonal line, with flat strokes at the top and bottom (see exploded view). The "s" is made in one stroke.

1. Begin at the waist line with the flat, left-right/right-left stroke that begins the "a" shape.
2. Turn the stroke downward to the right (with the twisted ribbon), and bring the pen toward the base line in a strong, straight, narrow diagonal.
3. Just before reaching the base line, curve the stroke to the left (with the twisted ribbon), ending with a short, flat stroke along the base line.

Accuracy Check

1. If your letter resembles (A), then the top and bottom curves are too pointy; remember to create the twisted-ribbon effect at the turning points.
2. If the center stroke is too wide, as in (B), the letter will be too upright.
3. The top and bottom strokes should be flat; they should not be curved, as in (C).
4. The "s" fits into a 7° parallelogram.

The Letter "t"

This letter is an exception because it rises above the waist line without using a true ascender stroke.

1. Begin approximately one nib-width above the waist line and make a simple 7° downstroke to the base line.
2. Meet the base line and end with a hairline upstroke to the right.
3. Cross the "t" just below the waist line, with more of the crossbar on the right of the downstroke (exactly like the crossbar of the "f").

Accuracy Check

1. The entire letter should be on the 7° axis.

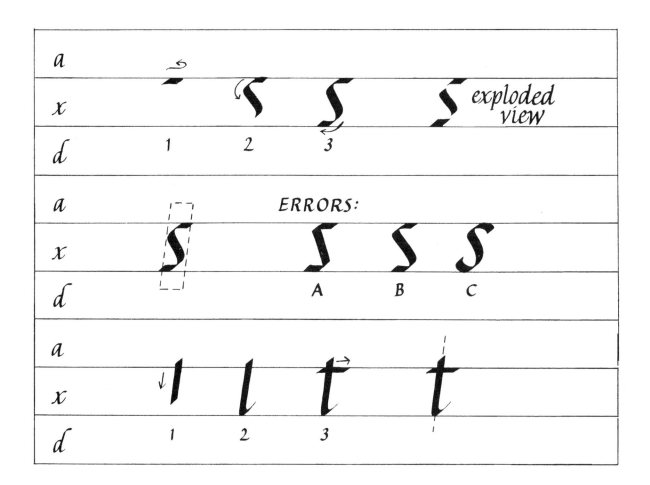

exploded view

ERRORS:

A B C

The Letter "v"

The 7° axis should bisect this letter.

1. Begin with a lead-in hairline upstroke, turning down into a stroke slanted very slightly to the right.
2. From the base line, overlap the downstroke for a small fraction as you bring the pen upward. Continue toward the waist line on an angle to the right that is slightly greater than 7°. This is *not* a straight line, but consists of two subtle curves at the top and at the bottom (see illustration).

Accuracy Check

1. If the first stroke is on the 7° axis, the entire letter will be too slanted, as in (A).
2. If the first stroke is too diagonal to the right, the letter will stand up straight on the base line, as in (B).

The Letter "w"

This is essentially a double "v." It is almost twice the width of the "v."

1. Start with the first stroke of the "v" (the downstroke). From the baseline, make an upstroke similar to the upstroke of the "v," but without curving the top of the stroke to the left. Move the pen back down along this stroke *slightly* (i.e. overlap the stroke you just completed) before making a second downstroke, parallel to the first downstroke. Complete the "w" with the same upstroke shown in the "v."
2. As you complete the circular motion, continue down and make the second "v" shape.

Accuracy Check

1. The two downstrokes and the two upstrokes of the "w" should be parallel, and the counters should be equal.
2. If you fail to overlap the first upstroke before you start your downstroke, the "w" will be too wide, as in (A).
3. If the second and fourth strokes (the upstrokes) are too slanted, your letter will lean too much to the right, as in (B).
4. Remember that none of the strokes of the "v" and the "w" are on the 7° slant.

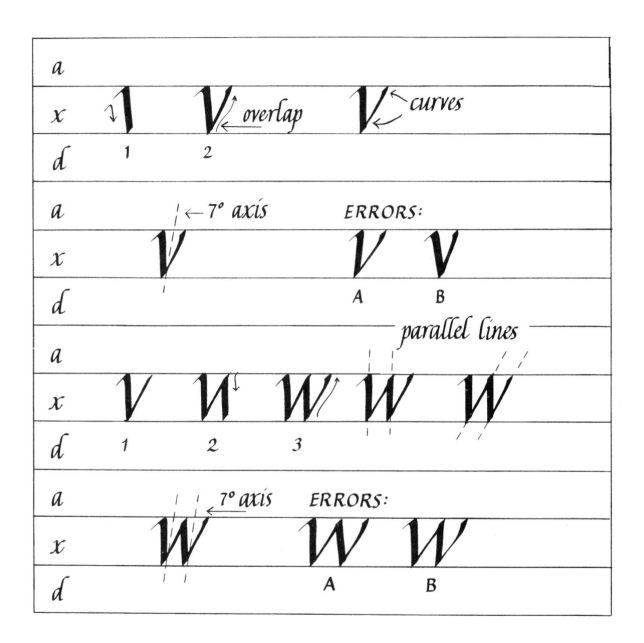

Like the "v" and the "w," the "x" is not on the 7° slant, but is bisected at the middle cross-point by the 7° axis.

1. Begin with a hairline lead-in stroke to the waist line, followed by a straight diagonal downstroke to the right which ends in a hairline upstroke.
2. The second stroke begins at the waist line with a very short, flat stroke (left-right/right-left, as in the "a" shape), leading into a diagonal stroke to the left and ending with another short, flat stroke along the base line. This stroke intersects the first stroke just above the center of the x-height space, so that the top and bottom counters are visually equal.

Accuracy Check

1. If the first stroke is too wide, as in (A), then the entire letter will be too wide.
2. If the first stroke is too narrow, the letter will lean too much to the right, as in (B).
3. If the second stroke intersects the first stroke too low (because it is too slanted or too straight), then the top and bottom counters will not be equal, as in (C).
4. The 7° axis should evenly bisect the letter at the cross point.
5. The letter should fit into a 7° parallelogram.

The Letter "z"

The last letter of the alphabet is a simple form, made in one stroke.

1. Begin with a short hairline upstroke to the waist line, leading into a straight line to the right, directly under the waist line.
2. With a sharp turn, make a diagonal downstroke to the left.
3. Touch the base line and end with a flat stroke across to the right, with a hairline upstroke at the end.

Accuracy Check

1. The top stroke should be slightly shorter than the bottom stroke.
2. Although no strokes are on the 7° slant, the entire letter should fit inside the 7° parallelogram.

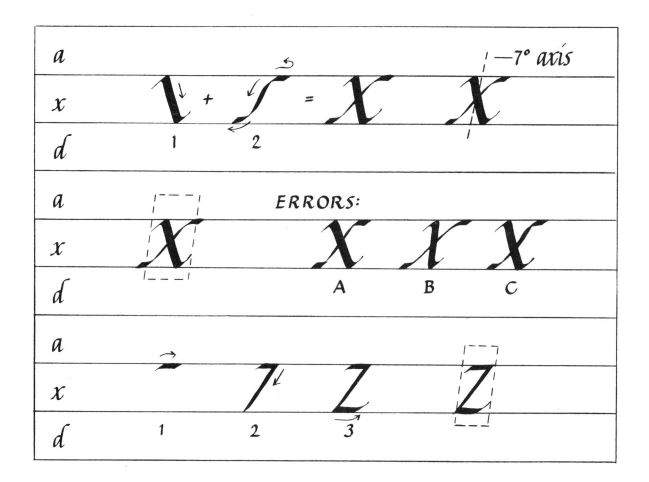

a

x I + \int = X X —7° axis

d 1 2

a ERRORS:

x X X X X

d A B C

a

x 7 Z Z

d 1 2 3

Spacing and Connections, Necklaces, Words and Sentences

Spacing and Connections

You've learned the minuscule alphabet and you're ready to begin making words. You may have experimented already with joining letters; you may even have tried writing a whole sentence or more. But something probably didn't look right, and that "something" is the letter connections and the spacing between the letters and words. When you are writing a word, a line, or a page of calligraphy, proper connections and spacing are imperative.

When writing the formal Italic hand you must always lift the pen off the paper between letters. Between each letter there should be a space that is equal to the width of the counter of an average minuscule letter (e.g., the inside of the letter "a"). Letters are connected by extending the endstroke so that one letter *appears* to be joined to the next.

You may connect out of (to the right of) the letters a, c, d, h, i, k, l, m, n, t, and u, because they all end with an upstroke from the base line and to the right. They connect easily into all the letters except s, v, w, x, and z, because these letters do not provide an easy joining point on their left sides. As you work you will soon see why it is difficult to join into these letters from their left.

The basic rule for making connections is logic. If a letter ends on the left (such as the b, p, and s), or below the base line (such as the g, y, and q), they cannot be joined into the letter that follows them, unless the letter that follows starts with a hairline stroke which can be attached to the preceding letter. Thus, an

ab ac ad ae af ag

ih ii y ik il im in

uo up uq ur ut uy

NOTE exceptions:

as av aw ix iz

applies to a, c, d, h, i, k, l, m, n, t, & u

"r" can be attached to a "b," but an "a" cannot. Sometimes several letters in a row will not connect, as in the word *good*.

Connections and proper spacing are inseparable. To connect properly you must space properly, and to space properly your connections must be correct.

When deciding which letters to join, you must use logic and aesthetic visual judgment; it must look and feel right. *Never* distort a letter to make a connection.

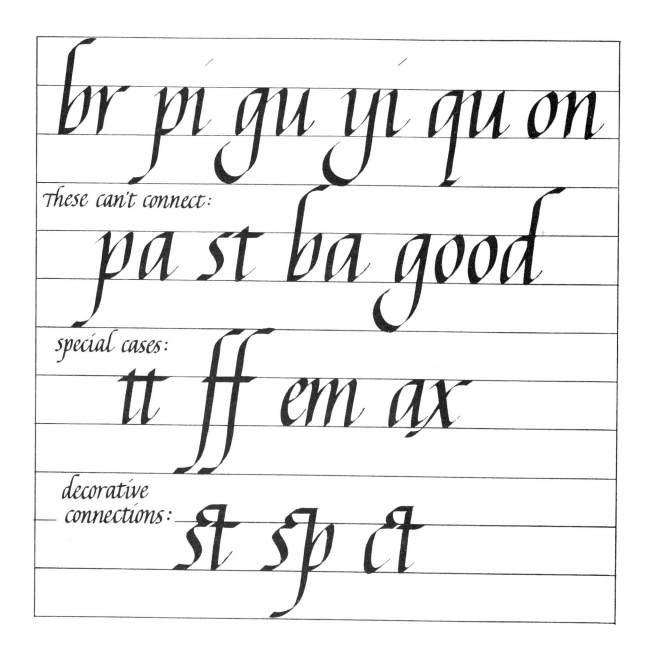

Necklaces

A good way to practice spacing and connections is to make "letter necklaces"—a method of alternating one letter between each successive letter of the alphabet to form a chain. This is a good way to practice any letter that may be giving you trouble. You'll also begin to see the method of connections: Notice that many of the letters in the "o" necklaces do not connect; most of the letters in the "n" necklace do. Try a "g," "s," and "x" necklace.

aobocodoeofogohoi

ojokolomonopoqoro

sotouovowoxoyozo

anbncndnenfngnh

ninjnknlnmnonpn

Don't join these!

gnrnsntnunvnwnx

Slow down! You are probably not writing as slowly as you were before. When you begin writing necklaces and words your confidence and your speed will begin to pick up. However, only by writing slowly will you be able to concentrate on accurate letter forms and even spacing.

Words and Sentences

Words are written exactly like necklaces. The space between words should be approximately the width of one average minuscule letter. This means that it is just a bit wider than the space between letters. As always, consistent and equal spacing is the key.

The following is a list of ten practice sentences, each of which contains all the letters of the alphabet. Try writing them slowly but rhythmically, concentrating on the shapes of the letters and the relationships among them:

1. A quick brown fox jumps over the lazy dog.
2. The five boxing wizards jumped quickly.
3. Pack my box with five dozen liquor jugs.
4. Seven wildly panting fruit flies gazed anxiously at the juicy, bouncing kumquat.
5. A pox on you, Jergens, old beanbag, you've squashed my favorite zwieback.
6. Dave quickly spotted the four women dozing in the jury box.
7. Every exceptional zoo boasts a penguin, wolf, monkey, jaguar and the queer aardvark.
8. I quickly explained that many big jobs involve few hazards.
9. Jack quietly gave dog owners most of his prize boxers.
10. Judge Power quickly gave six embezzlers stiff sentences.

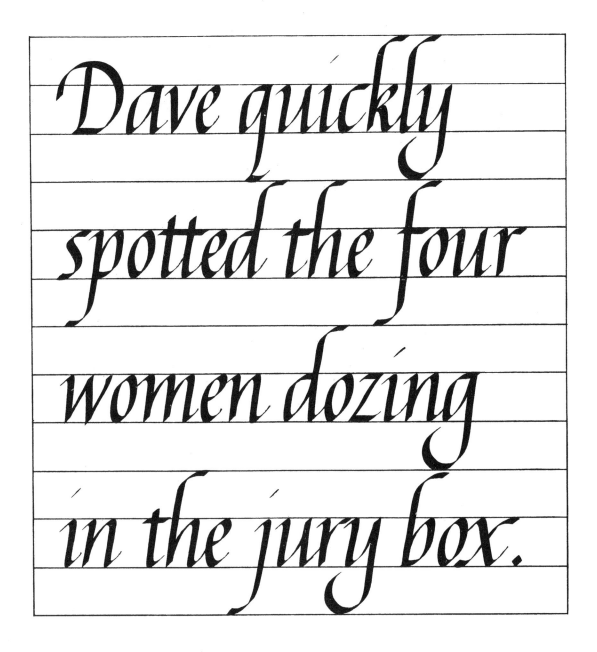

Dave quickly spotted the four women dozing in the jury box.

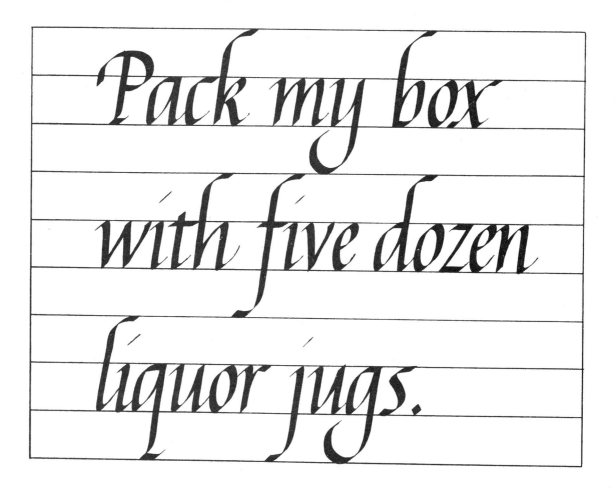

Since you haven't learned capital letters or punctuation yet, practice these sentences without them for now. Try them again after you complete Lesson 8.

The average beginner leaves too much space between words. The best way to test this is to write a sentence and look at it. Some people find that squinting at the page blurs the letters so that the spaces stand out.

If your spacing is incorrect, practice some of the sentences again. After you write a sentence, analyze and correct your work. Use a pencil to mark off any errors. Then, directly below that sentence, repeat the same sentence, paying careful attention to correcting your mistakes. You'll find the improvement is amazing.

As you practice writing sentences, concentrate on all the elements you have learned so far:
- pen angle
- letter slant
- counters
- spacing
- connections

LESSON 7 | *Swash Capitals*

There are two types of capital (majuscule) letters that may be used with the minuscule Italic alphabet: the swash capitals and the simple capitals.

The "swash" is a decorative stroke on the left side of many capital letters. It balances the body of these letters both visually and artistically. You will be learning to make swash capitals in this chapter.

The simple capitals are based on Roman letters. If you would like to learn the simple capitals, the appendix lists several reference books.

Characteristics of Swash Capitals

1. To remain consistent with the minuscule letters, swash capitals are also written on the 7° axis.
2. The widths of the capital letters vary, but as a general rule they are fairly wide, compared to the more compressed minuscules.
3. Capital letters are shorter than the ascender letters. They are never more than 7½ nib widths high (i.e., they never extend more than halfway into the ascender space). If you prefer, capital letters may be as small as seven or even 6½ nib widths high, as long as the height is consistent.
4. Most capitals are made in two or three strokes, with the swash (when applicable) made as the initial stroke or as the beginning of the second stroke.

This must be mastered as a separate stroke. It closely resembles the top and left sides of the "a" shape.

1. Place the pen just above the waist line and make a short 7° downstroke, followed immediately by an overlapping upstroke (this down-up stroke serves to get the ink flowing, just as the left-right/right-left motion in the "a" shape does).
2. Turn the stroke up to the right (with the twisted ribbon), ending with a flat stroke halfway into the ascender space, parallel to the waist line.

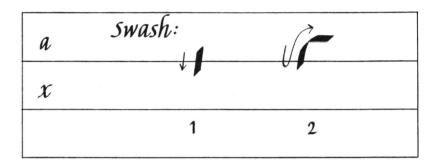

Practice the swash before you begin learning the capital letters. It is used with fifteen letters: A, B, D, E, F, H, K, M, N, P, R, T, U, V, and W.

In this chapter the instructions for making the majuscule letters are divided into five groups, according to letter form.

Group 1: B, D, E, F, P, R, T

The letters in this group all begin with the basic downstroke, made as follows:

1. Begin with a 7° downstroke from the center of the ascender space.

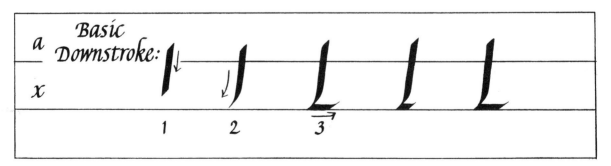

2. Just before reaching the base line, bring the pen very slightly to the left and then move immediately to the right and flat across the base line (this is similar to the bottom of the descender of the minuscule "q"). The length of this flat stroke varies with each letter.

3. End with a short hairline upstroke, which will be important for closing the letters in this group.

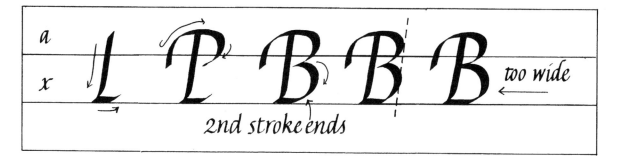

B (made in two strokes) Make the first stroke as described above. Then make the swash, continuing across to make the top of the letter. Curve this stroke in to the left, briefly meeting the downstroke at the center. Curve out and around again to meet the bottom hairline and close the letter.

Notice that the counters of both loops are equal. Beware of extending the bottom loop beyond the top loop, which will result in an unbalanced letter. The right side of the "B" should be on the 7° axis.

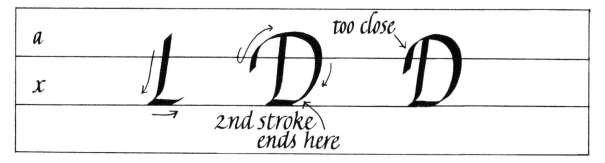

D (made in two strokes) Like the "B," begin with the basic downstroke. Begin the second stroke with the swash, continuing it around in a loop that meets the bottom hairline to close the letter.

Notice that the bottom of the "D" is longer than the bottom of the "B," and the letter is wider. Note also that the distance

between the swash and the downstroke must be wide enough to balance the letter. If the swash is too close, your letter will appear unbalanced.

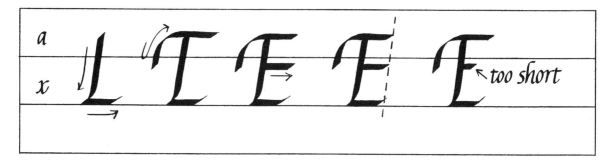

E (made in three strokes) Begin with the basic downstroke, with a line across the bottom that is slightly longer than the bottom of the "D." Extend the swash stroke across the top in a length equal to the bottom stroke. The third (center) stroke must be the same length as the top and bottom strokes. The right side of the "E" should be on the 7° axis.

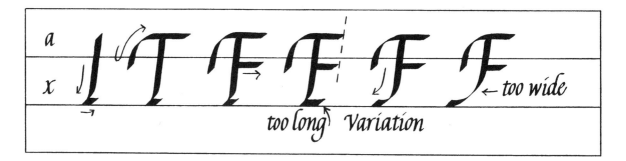

F (made in three strokes) Begin with a basic downstroke that ends with a very short cross stroke. Be sure that the cross stroke is large enough to support the letter. The second and third strokes are the same as the "E"s: They are of equal length. If the bottom cross stroke is too long, the letter may be mistaken for an "E."

Variation: Instead of ending the downstroke flat on the base line, swing the stroke out to the left just before reaching the base line. Be careful that you do not make this curve too wide, or the letter will be off balance.

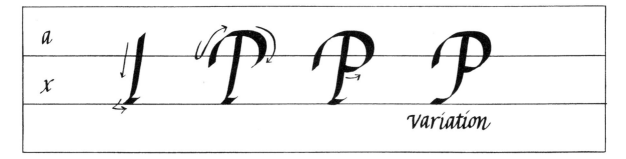

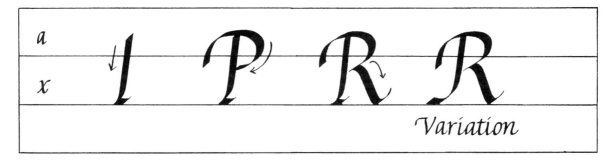

P (made in three strokes) Begin the second stroke as if you are making a "B," but stop with a hairline just as the stroke starts to curve to the left. Move the pen to the center of the downstroke and make the final stroke from left to right, closing the curve to create the twisted ribbon.

R (made in two strokes) The "R" is made with the same basic downstroke as the "F" and "P." The second stroke starts with a swash that continues around and curves in to the left, meeting the downstroke at the center (exactly like the first loop of the "B"). It then continues down to the right with a slightly curved stroke that ends in a hairline upstroke.

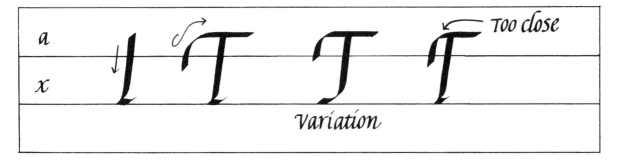

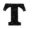

T (made in two strokes) The "T" is made with the same basic downstroke as the "F," "P," and "R." The second stroke begins

with the swash and continues in a flat cross stroke parallel to the base line. Be sure that the swash is not too close to the downstroke or the letter will be off balance.

Variations: The "P," "R," and "T" may be made with the same downstroke variation as the "F."

All of the letters in this group begin with a swash.

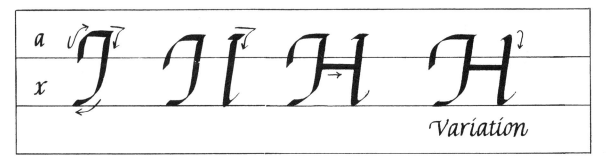

A (made in three strokes) Begin with the swash stroke. At the top end of the swash, pull back slightly to give the "A" its point. Bring the stroke down to the base line in a fairly wide diagonal, ending flat. Note the twisted ribbon right above the base line.

Placing the pen at the top of the downstroke, make a second downstroke in a diagonal slightly to the right. End with a hairline upstroke.

The crossbar is made at a point slightly lower than halfway between the top of the "A" and the base line, so that it divides the space in half visually.

H (made in three strokes) The first stroke is similar to the first stroke of the "A," but it is on the 7° slant. The second stroke is a parallel downstroke. It begins at the same height as the swash, with a small, left-right movement forming a short, flat stroke on the top. The stroke continues to the base line on a 7° slant, ending with a hairline upstroke. End the letter with a flat crossbar, starting in the center of the first stroke and moving to the right.

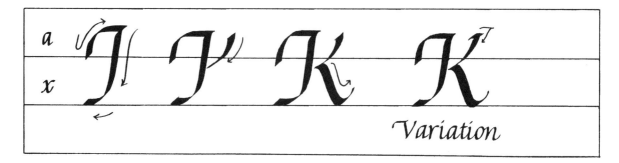

K (made in two strokes) The first stroke is the same as the first stroke of the "H." The second stroke starts at the same height as the first stroke, moving diagonally downward to the left, meeting the first stroke at the center. Bring the stroke down to the right, curving it very slightly (like the "R"). End with a hairline upstroke.

Variation : Like the "H," begin the second stroke with a flat cross stroke at the same height at the first stroke.

M (made in two strokes) The first stroke is made exactly like the first stroke of the "A." Begin the second stroke at the top point, moving down to the base line, up to the top, and back down to the base line, all in one stroke. Note that the first and third lines are parallel, and the second and fourth lines are parallel. The two lower counters should be visually equal, and a 7° axis through the bottom point should divide the letter in half.

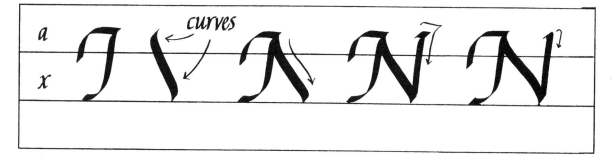

N (made in three strokes) This letter begins exactly like the "H," with a swash and a 7° downstroke to the base line. The second stroke begins at the right-hand corner of the swash, coming down to the right on a diagonal. There are two subtle curves at the beginning and end of this stroke (see illustration). The first curve overlaps the point of the swash (so it is nearly invisible in the final letter), and the second curve will be overlapped by the third downstroke. The final stroke is a downstroke starting with a short, flat cross stroke.

Variation: Begin the third downstroke with a small curve, similar to the entrance stroke used in the minuscule letters.

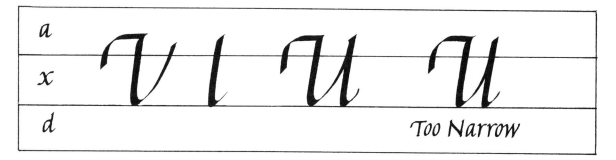

U (made in two strokes) The "U" starts with the swash and downstroke of the "H." As the stroke touches the baseline it curves around and up to the right in a form similar to the minuscule "a" shape, only wider and higher. End the stroke a little below the top of the letter.

The second stroke starts like a minuscule "t" (only taller) and ends like the "H" with a hairline exit stroke.

These letters all start with a 7° downstroke.

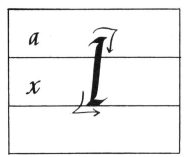

I (made in one stroke) This is a simple 7° downstroke that begins and ends with flat cross strokes.

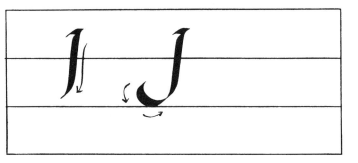

J (made in two strokes) The first stroke is exactly like the "I," with a curve to the left as you near the base line, ending with a hairline. The second stroke is made from left to right, beginning just above the base line and curving around to meet the first stroke.

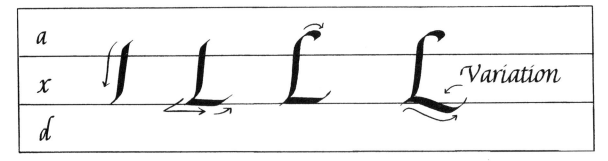

L (made in two strokes) Begin with a hairline, curving slightly to the left into a 7° downstroke that ends like the bottom of the "E." The top of the "L" is made with a small left-right stroke that curves very slightly downward.

Variation: The bottom of the first stroke may intersect the base line in a curved line, slanted downward.

These letters are all based on the "O" form.

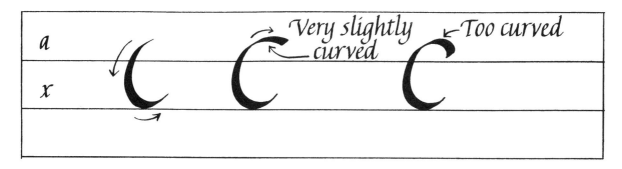

C (made in two strokes) Begin with a hairline, slightly below the full height of the letter. Curve around to the left, down to the base line, and end with a hairline up to the right. The second stroke begins at the same place as the first stroke, moving from left to right in a slight curve. Be careful not to curve this stroke too much.

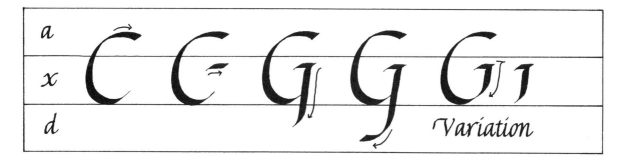

G (made in three strokes) Begin by making the complete "C." Then place the pen midway between the top and bottom of the curve and make a short left-right stroke. Briefly overlap this short stroke (from right to left), and move the pen down at a 7° angle, covering the endstroke of the "C" as it continues down two-thirds of the way into the descender space. Turn the stroke to the left with a twisted ribbon, and end with a stroke similar to the bottom of a minuscule "j."

Variation: The third stroke of the "G" may curve in before reaching the base line, and end as it connects with the hairline of the "C" form.

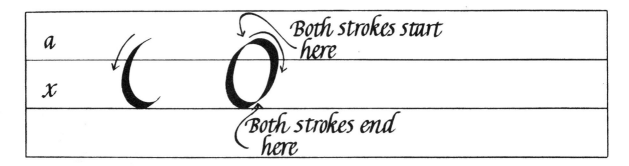

o (made in two strokes) The first stroke is the same as the first stroke of the "C." Begin the second stroke at the top of the first stroke, with a curve that continues out to the right, down, and around.

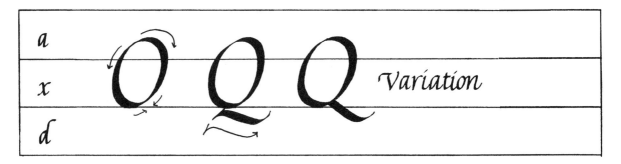

q (made in three strokes) Start with a capital "O." From the center of the bottom of this "O," make a short diagonal hairline, heading toward the lower left. Pause and push back up along this hairline and immediately curve to the right to make the tail of the "Q." The tail should be a straight line that begins and ends in a curve (see illustration). It is a diagonal, but only occupies a small part of the descender space.

Variation: The tail can begin on the lower right side of the "O," where the two strokes meet. It will intersect the baseline.

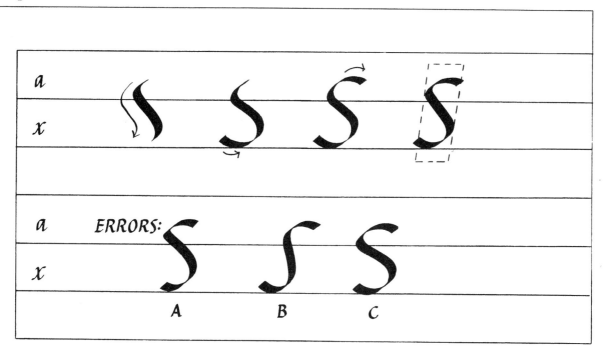

S made in three strokes) This letter starts with a diagonal stroke that begins and ends with a curve, like the tail of the "Q"—curve, straight, curve. The stroke begins and ends with a hairline and stops before the baseline. The second stroke is a curve along the baseline from left to right meeting the first stroke to form a rounded counter. The third stroke is also a curve from left to right, just like the top of the "C."

The "S" fits perfectly into a 7° parallelogram. If the center curve is too wide, the letter will lean too far to the left, as in (A). If it is too narrow, it will lean to the right, as in (B). If the center curve is too flat, the letter will be too wide, as in (C).

Note: "V" and "W" form a group. Both are made with a swash, but the angle of the downstroke is different from those of the other swash letters.

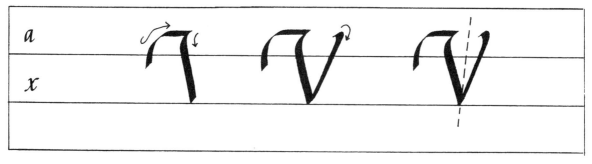

V (made in two strokes) Begin with a swash stroke, pulling back slightly to the left before beginning the downstroke. This will form a point at the top of the letter (as in the "A"). Continue into

a downstroke that is slightly diagonal to the right, ending at the base line.

The second downstroke begins at the same height as the swash, with a small curve to the right that turns immediately into a downstroke. This meets the first stroke at the base line and forms a point. Note that a 7° axis bisects the letter.

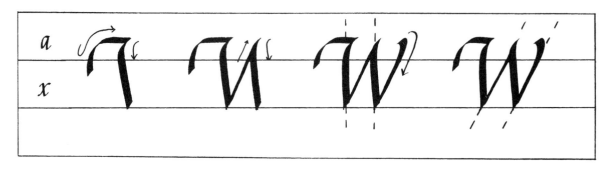

W (made in two strokes) Begin with a swash and downstroke exactly like the first stroke of the "V." Without lifting the pen off the page, continue from the base line into the upstroke. Overlap this stroke slightly (as in the minuscule "w") and continue into the second downstroke, stopping at the base line. Make the final stroke exactly like the second stroke of the "V."

As in the minuscule "w," the downstrokes and the upstrokes are parallel, and the counters are equal.

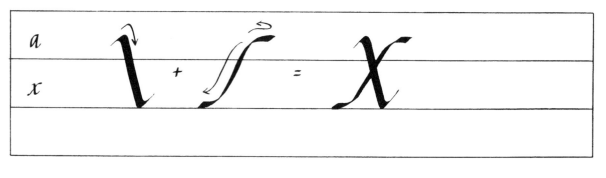

 (made in two strokes) This is exactly the same as the minuscule "x," only larger.

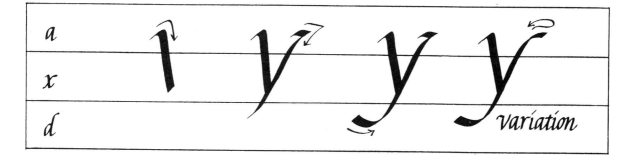

Y (made in three strokes) The first stroke is a diagonal to the right, at the same angle as the first stroke of the "X," stopping just short of the base line. Begin the second stroke with a short cross stroke from left to right, reversing immediately into a left-diagonal downstroke that meets the first stroke at the base line and continues one-third of the way into the descender space. End with a hairline curve to the left. Curve back to meet the hairline with a left-right stroke in the descender space.

Z (made in one stroke) This is made like the minuscule "z," with a slightly curved upstroke on the end.

Variation: The bottom of the "Z" can be made with more panache by curving the stroke and making it diagonal, intersecting the baseline. Be sure that the stroke is essentially a straight line that begins and ends with a curve, like the tail of the "Q."

Numbers and Punctuation

There are two sets of numbers that may be used with the Italic hand: lining numbers and old-style numbers.

The lining numbers all sit on the base line and ascend to the height of the capital letters—never higher, although they may be slightly smaller.

Old-style numbers move up and down: Some begin in the ascender space and sit on the base line; others begin at the waist line and end in the descender space; and some fit exactly between the waist line and the base line. They also vary in size.

Both sets of numbers are on the 7° slant.

Lining Numbers

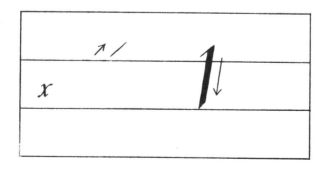

1 (made in one stroke) This begins with a short hairline upstroke, followed by a simple 7° downstroke to the base line.

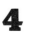 **2** (made in one stroke) Note that the bottom of the "2" is flat (it does not curve along the base line), with a slight lift off the line at the end of the stroke.

Variation: The "2" can start with a small down-up stroke like the beginning of the swash.

3 (made in two strokes) The second stroke is a short left-right curve that meets the first stroke. Note that the bottom counter of the "3" is slightly larger than the top counter.

4 (made in two strokes) Begin with a diagonal stroke to the left that turns sharply to the right about halfway into the x-height space. This stroke ends with a short hairline upstroke. The second stroke is a 7° downstroke, crossing the horizontal line of the first stroke.

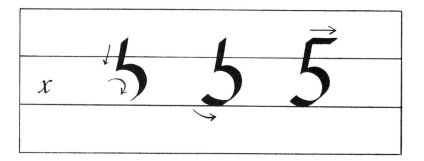

5 (made in three strokes) Note that the top left-right stroke overlaps the first stroke so that there is a solid connection. The bottom of the "5" is the same as the bottom of the "3," with the left-to-right curve meeting the first stroke.

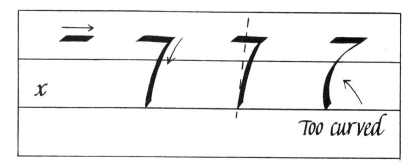

6 (made in three strokes) Start with a curved downstroke that begins and ends with a hairline (this is the same as the first stroke of the capital "O"). The second stroke is the bowl of the "6"; it begins with a slightly curved upstroke and continues around in a wide curve, meeting the first stroke. The third stroke is made from left to right, exactly like the top of the "S."

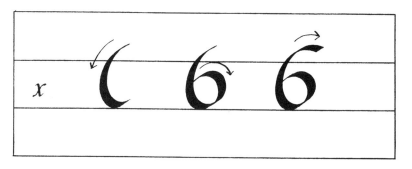

Too curved

7 (made in one stroke) This begins with a left-right cross stroke that turns sharply into a slightly curved downstroke. Note that the bottom point of the stroke should be on a 7° axis with the middle of the top stroke. If you curve the downstroke too far to the left, the "7" will be off balance.

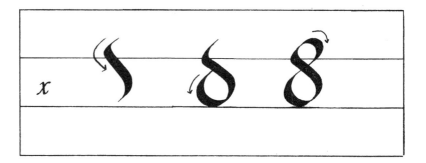

8 (made in three strokes) The first stroke is an S-curve, made exactly like the first stroke of the capital "S." The top and bottom curves must be made separately; the bottom counter is larger than the top.

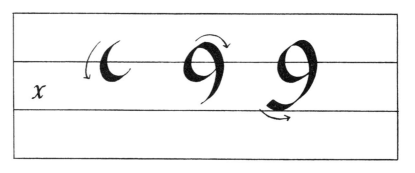

9 (made in three strokes) This is an upside-down "6," beginning with the bowl. The second stroke is a large curve to the right, ending with a hairline (like the second stroke of the capital "O"). The third stroke is a curve from left to right, meeting the second stroke.

0 (made in two strokes) This is made like the capital "O," but slightly narrower.

Refer to the illustrations below for positioning of the old-style numbers. They are made the same way as the lining numbers, except for the 0, 1, and 2, which are shorter; these three numbers fit exactly into the x-height space. The "0" is slightly wider than the lining number "0."

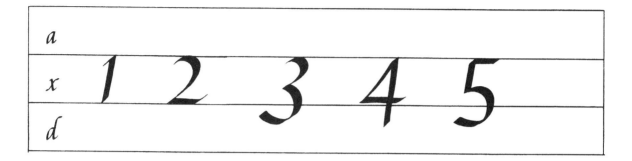

Note that the 3, 4, 5, 7, and 9 extend approximately two nib widths below the base line, with their tops at the waist line. The "6" and the "8" sit on the base line, extending approximately two nib widths above the waist line.

Old-style numbers are lively, but must be used with care. Beware of numerical sequences that consist mainly of the short numbers (0, 1, and 2), where a single large number may appear to be an error.

This looks like an error.

Spacing Numbers

The space between numbers should be approximately twice the space between letters, as shown in the examples.

Due to their simplicity, numbers are sometimes difficult to make perfectly. Practice a variety of number sequences. You'll be glad you've mastered numbers when you begin addressing envelopes.

Punctuation

With few exceptions, punctuation is made with exactly the same movements as those made with a regular pen or pencil; thus, they need little explanation. Remember to maintain the 45° pen angle.

The period looks like a small diamond, sitting on the base line.
The comma is a period with a hairline curve below the base line.
The semi-colon is a period on top of a comma, on the 7° axis.
The colon is made with two periods, placed one above the other in the center of the x-height space. The colon sits higher than the semi-colon.

Quotation marks are made in short, slightly curved down-strokes from the ascender line. The left-hand quotation marks curve to the left; the right-hand quotation marks curve to the right.

The apostrophe is a single quotation mark, curving to the right.

Parentheses begin a fraction above the ascender line and extend a fraction below the base line, so that they actually hold the words between them. They curve slightly.

The exclamation point extends to the full height of the capital letters, with a very small curve to the left at the bottom of the downstroke and a period at the base line.

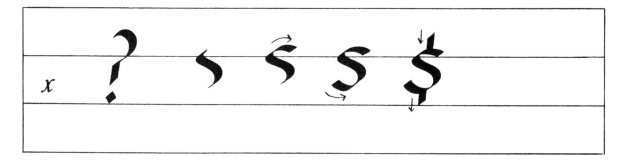

The question mark is in the same position as the exclamation point; it consists of a curve followed by a short downstroke with a period at the base line.

The dollar sign is made in five strokes. Begin with a short, fat "S" (made in three strokes); add the top and bottom strokes.

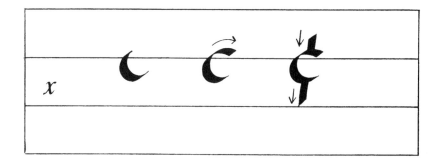

The cent sign is made in four strokes. Begin with a small, round "c" (made in two strokes); add the top and bottom strokes.

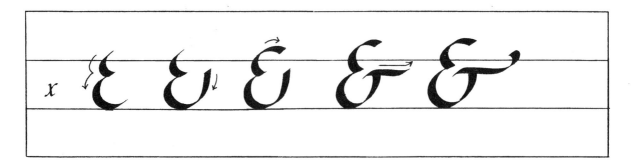

The ampersand is the Latin word *et*, meaning "and." The ampersand shown here is made in four strokes. The final cross stroke can be very decorative, curling up and out. For many other examples of beautiful ampersands, Arrighi's *The First Writing Book* is a very good reference source.

LESSON 9 | Changing Nibs, Writing in Color, Making Corrections

Changing Nibs

A variety of nibs allows you to write in a wide range of sizes. It is not unusual to use several nibs for a single piece of work.

To repeat what you learned in Lesson 2, the height of the letter is in a constant proportion to the width of the nib: the x-height is always five times the nib width. The larger the nib the larger the letters, and the smaller the nib the smaller the letters.

0 ~ nib

With practice, you will see that taller letters are also proportionately wider, and that the relationship between the counters and the weight of the letters remains constant. Ideally, different-sized letters should look like photographic enlargements or reductions of one another.

To determine the x-height for any broad-edged nib, make five nib marks on your page, stacked corner to corner on top of one another. The distance from top to bottom equals the x-height.

Try making these marks and measuring the x-height for nib Nos. 0, 3, and 5. Compare your measurements with the examples shown.

3 ~ nib

Medium-sized nibs (No. 2½ or 3) are the easiest sizes to work with. Writing with the No. 0 nib is harder, but it is worthwhile because the letters are so large that your errors are magnified. Conversely, smaller nibs (No. 5 or 6) make it more difficult to see the subtleties of the letters; if they are not made accurately, you may be unable to distinguish between thick and thin lines. The smaller nibs also tend to be sharp, and beginners sometimes

5 ~ nib

find the nib catching on the paper and spreading the ink. Remember to continue writing slowly, no matter what size nib you are using.

The 7° slant remains constant as you change nibs, as does the 45° pen angle. When you change nibs you must *always* measure and draw correct new lines.

Making a Paper Ruler

You can make a simple paper ruler for any new nib you use. To do this you'll need pen and ink, a well-sharpened 3H pencil, and a strip of paper approximately two inches wide by eight inches long. One of the paper edges must be machine-cut, not torn.

Begin by making your five nib marks along the machine-cut edge of the paper strip. Use those marks to measure and mark off one x-height space onto your work page.

Now measure this distance, from the work page, back onto your paper strip, so that you have two spaces measured onto your paper strip.

Use those two marks on the paper ruler to make two new marks on your work page; then measure and mark those onto your paper ruler. Your paper ruler now has four lines, which you use to measure four more lines onto your work page, etc. Following through with this process, you'll soon have your page marked off, and you'll have a paper ruler for future use with that nib.

Remember to write the correct nib number on the ruler for future reference.

Note that a paper ruler will not work well for nibs smaller than the No. 4, because the measurement marks can blur. For smaller measurements, you'll have to use a metal ruler.

Writing in Color

Color is one of the great joys of calligraphy. You may wish to write an original piece entirely in color, or use color to contrast with black for emphasis in a piece. Whatever your reasons for using color, you will have fun experimenting with some new materials.

Tools for Color

Gouache:

(also called "designer color") This is an opaque, water-based paint that comes in small tubes and may be bought in most art supply stores. Recommended brands of gouache include Winsor & Newton, Schmincke, Turner, and Holbein. The price of a tube of gouache varies depending on color; some pigments are more expensive than others. Prices are not low, but a small tube of paint should provide you with quite a lot of color. Try to select colors that are permanent, i.e. will not fade when exposed to light. Good quality gouache will be smooth and easy-flowing, and the color will often be brilliant and luminous.

Keeping in mind that red and black are "calligraphers' colors," cadmium red pale is a good choice for your first color experiments. Golden yellow and ultramarine should also give you good results.

Nib:

Use a brand-new, clean nib for working with color. A nib that has been used for ink will pollute your colors.

Paintbrush:

A thin (No. 1 or 0), watercolor paintbrush is necessary for working with gouache. It need not be expensive, but the bristles must be soft.

Small Dish:

You'll need this for mixing the gouache.

Water Container:

Keep a separate water container for rinsing your color nibs.

To Use Gouache

1. Squeeze a small amount of gouache into your mixing dish. Use the paintbrush to add a few drops of water to the paint, mixing well until it has a semi-runny consistency. It should have about the same consistency as ink.

 It will take some practice before you learn to mix the paint properly. Each time you work with gouache it will probably take several tries before you get the proper consistency. When it is right, your colors are clear, smooth, and brilliant.
2. Hold the pen with the reservoir facing up, and use the paintbrush to drip paint under the reservoir until it is full.
3. Test your paint on a piece of scrap paper. If the consistency is too thin, the paint will run or flow too quickly. If it is too thick, your pen will not write. Proper consistency will make the paint flow evenly from the pen.

A TIP

You must rinse and dry your nib more often when working with gouache because it dries on the pen even faster than ink.

Colored Ink

Colored ink can be fun for experiments with a dip or a fountain pen, but the color quality of ink is vastly inferior to that of gouache. Compare writing with red ink versus red gouache; you'll immediately see why gouache is better. Avoid waterproof colored inks; they usually give poor results.

Knowing how to correct your errors is important. Many calligraphers find that concentrating on the detail and shape of the letters often leads to simple spelling errors or the omission of words. Beginners are often surprised to see that they've misspelled their own names!

There are four methods of making corrections: painting out and pasting over, which are used only on work that is done for reproduction (printing); and erasing and scraping, which are used for correcting small errors on original work.

Painting Out

These instructions are specifically for making small corrections, such as an incorrect stroke or shape in a single letter. If you omit a letter or word, the best thing to do is start over; this will ultimately be less frustrating than trying to make large corrections.

Tools

1. A small jar of water-based bleedproof white. Among the brands available are Dr. Martin's, Luma, and Winsor & Newton; other brands should work as well. *Do not* use "white-out" correction fluid; it is not water-based, and is too thick for making most corrections.

2. A good-quality, fine point, watercolor brush (No. 0 or 00). The tip of the brush must come to a small point when wet. Do not use this brush for any other purpose.

3. A spray can of Krylon Crystal Clear (an acrylic coating).

Method

1. Rewrite the correct stroke(s) or letter directly over the incorrect lines.

2. When the ink dries, spray the entire page with a light coat of Crystal Clear. Let it dry before using the bleedproof white. The purpose of the Crystal Clear is to keep the paint from "bleeding" into (mixing with) the ink. Although theoretically bleedproof white should not mix with the black ink, sometimes a little bleeding does occur.

3. Using the brush and white paint, paint out the incorrect strokes or parts of letters.

4. If the white paint turns gray on the paper, allow it to dry and add a second coat.

A TIP

When making corrections, turn the paper into the most accessible position. Paint out from the right side or the top, so that you can handle the brush easily and see your work clearly.

Pasting Over

Errors can also be corrected by rewriting the word or line on another piece of paper and pasting it directly over the incorrect word or line. This must be done very carefully and accurately, using rubber cement and a T-square. It takes some skill and practice to do this well, but it is (usually) faster than rewriting the entire text.

Erasing

When you make an error on an original piece of work, you should first consider whether the mistake can be erased with a kneaded eraser, a plastic eraser, or similar tool. Test your various erasers on a separate sheet of the *same paper* as your finished art, to see if one is effective.

Scraping

This method is used mainly for deleting small edges or ragged lines. You can sometimes scrape the ink off the paper, leaving a cleaner edge or a more finely shaped letter. The only tool you need is a single-edged razor blade, or an X-acto knife.

Method
1. Test the blade as you would an eraser—on another sheet of the same paper.
2. Use the corner of the razor blade to scrape off the incorrect stroke or portion of the letter. Do this carefully, with a light touch.

Waterproofing

There is no product that we recommend that will make your calligraphy 100 percent waterproof without possible damage to the artwork (or to the environment). Waterproofing, moreover, isn't necessary unless your work will be exposed to outdoor elements or used where it may be carelessly handled.

If you are concerned that your calligraphy may be handled and perhaps smudged, you may want to spray it lightly with Krylon Crystal Clear. This will make it water-resistant rather than waterproof. Be sure to spray in a well-ventilated area and avoid inhaling the fumes.

LESSON 10 · *Using Your Skills*

You are ready to start using your calligraphy. The following are practical and artistic projects that you should be ready to try. Use the instructions and examples to guide you in creating new ideas and designs of your own.

Addressing Envelopes

This is often the first practical task that new calligraphers undertake.

Choose your nib size according to the envelope size. Most standard-sized invitation envelopes look best when addressed using the No. 4 or 5 nib.

You may draw and erase lines on each envelope, but a slip-in guide sheet is simple to construct and makes the job easier.

Slip-In Guide Sheet

You'll need a sheet of lightweight, white cardboard, cut approximately one-eighth inch smaller than the envelope—small enough to slide in easily but remain firmly in place.

The top of the first line of your addresses should begin approximately halfway down from the top of the envelope. Using a fine-point black marker, such as a Pigma Micron Fine Tip .01 or a Pentel Ceramicron, draw the lines on your guide sheet, measuring off the ascender, x-height, and descender spaces. Make three writing spaces, enclosed by four lines, for each line of writing. Put a large dot on each base line so that you can easily distinguish it from the other lines. Twelve spaces are enough for most standard addresses.

Draw a diagonal line along the left side of the guide lines, as shown in the illustration below. Use this diagonal to graduate the left margin of the address to the right.

Tape the upper edge of the guide sheet to a larger piece of firm cardboard. This keeps the guide sheet firmly in place and also gives you a slightly padded surface on which to work. You can now flip the guide sheet up and slide the envelope onto it without having to handle the envelope too much. When you insert the slip-in guide sheet into a white or cream-colored envelope, you will be able to see the guide lines through the envelope.

A TIP

Do not buy envelopes with a thick decorative lining (such as shiny or colored paper); you will be unable to see through to the lines on your guide sheet.

The addresses should end no less than one-half inch from the bottom of the envelope and should be reasonably centered from left to right. Don't drive yourself crazy trying to center addresses perfectly; after a while you'll be able to judge it correctly by eye.

Centering Words and Lines

This technique is important for many projects. Each word or line that is to be centered must be measured separately. This is done most easily with graph paper and a ruler.

Method

Determine which nib you will be using and mark off the appropriate lines on your graph paper. Then write the word or line, paying careful attention to spacing. This will be your sample guide.

Mark off the center point of your writing line on the finished piece (e.g., a place card or certificate). If you are centering several lines, draw a center line down the page in pencil.

Measure the length of the word(s) you've written on the graph paper, and divide this measurement in half. Write this number at the end of the line(s).

Now mark off the distance to the right and left of the center point for each line that you are going to write on your finished piece. For instance, if a word is four inches long, mark off two inches to the right and the left.

When you write the word or phrase onto the finished piece, it is a good idea to place the practice piece directly above or below the rewrite, referring to the example so that the new spacing matches as closely as possible. You will usually have to write things twice when you are centering; if you are making a sign or invitation that requires each line to be centered, you will have to repeat this process for each line. Do not trace your first sample onto the final piece—tracing distorts letter forms.

A TIP

There is a shortcut for centering a series of names (e.g., for place cards) or phrases that are similar in length. First type all the names in a column with an even left margin. Generally, words that are of equal length typed will be of equal length in calligraphy; you can therefore use the same measurement for all the names or phrases that are of equal length. An exception would be names such as Billy and Tammy. The same measurement could not be used to center both names because "m"s are wider than "l"s or "i"s.

Many fine papers come in a variety of shapes, sizes, and colors. Often the pieces are large enough to be cut and used for several pieces of work. Always cut the paper after you have completed your work, so you can be sure there is enough space around your writing.

Tools

1. A new, single-edged razor blade, or an X-acto knife.
2. A metal ruler with masking tape on the back. This will keep your ruler from slipping and prevent you from cutting something that you hadn't intended to cut.

Method

Place a piece of cardboard under your work. Stand up to cut and remember to never cut toward yourself.

Rule cutting lines lightly on the art work and cut along these lines using your metal ruler and razor blade. Always keep your ruler between the art work and the blade so that if you cut inaccurately you will not destroy the art work.

Press firmly on the ruler and hold the blade lightly. Cut the paper making several light strokes with the blade.

Alphabet Borders

For greeting cards, personal stationery, signs, or posters, alphabet borders are appropriate, attractive, and easy to make. Written around all four edges of a page, they may consist of one repeating letter, two letters (such as your initials), an alphabet necklace, a name, a poem, a message (such as "Happy Birthday," "Merry Christmas," or "I Love You"), or anything you may want to use to decorate your work.

Choose a nib according to the size of your page. As a general rule, smaller letters (such as those made with a No. 4 or 5 nib) will be more effective than larger letters. Also, it is a good idea for the border to be written smaller than the other calligraphy on the page.

Depending upon the size of the paper, allow for a one-half-inch to one-inch margin on all sides (with a little more on the bottom) before carefully ruling four lines around the entire edge of the page. Since there is only one line of writing, you will only need three spaces for a simple alphabet border. If you wish to make a double or triple border, draw lines accordingly.

Birthday Happy Birthday Happy

Happy Birthday Happy Birthday Happy Birthday Happy

Happy Birthday Happy Birthday Happy Birt

Happy Happy Birthday Happy Birthday Happy Birt

Beth Mary Beth Mary Beth Mary

A TIP

Stationery

To make personalized stationery, make an alphabet border using your name or initials, written in black ink on white paper. You may wish to put your name and address at the top or bottom of the page, centered or off-centered; with or without an alphabet border. Make your work as clean as possible: If it needs retouching, use the methods described in Lesson 9.

Bring this page to an off-set printer. From your black-on-white original, stationery may be printed in colored ink and/or on colored paper. The printer can show you a choice of papers and colors in several price ranges.

With a good-quality copy machine, personal stationery may be made with little expense, although your choices of paper and colors will be more limited.

Writing Out a Quote, Passage, or Poem

When working on a piece of original art there are some basic points to keep in mind that are useful for the beginner as well as for the experienced calligrapher.

1. Keep it *simple*. A short passage, carefully written and well spaced, looks much better than a page of elaborate flourishes, poorly done.
2. Leave plenty of white space around your writing. Allow an equal amount of space at the top, left, and right margins, with a slightly larger bottom margin.

3. The minimum space between base lines should be the height of one ascender and one descender. Thus, you will be writing in every third space, just as you did on your practice pages. Try leaving more space between lines; either an extra five nib-widths or perhaps two or three nib widths. Compare your experiments and decide which looks best. Always rule your lines carefully.

4. Make several drafts. Your first copy should be written on graph paper, to see how long and wide the finished piece will be. Measure the length of the longest line and the depth of the piece from top to bottom. Add at least 1½" to 2" of margin space on each side. Try making scaled-down sketches on graph paper to see the relationship between black (the writing) and white (the space around it).

5. Go to exhibits, look at calligraphy books (especially primary sources from the masters), join a calligraphy society, or take a class. The more you see the more you'll learn, and the more ideas you'll get.

In Conclusion

By now you probably notice calligraphy everywhere: restaurant menus, posters, flyers, envelopes, and party invitations. You are no doubt beginning to develop a critical eye and are able to assess your own calligraphic strengths and weaknesses. You are also finding out how much work and how much fun it is to learn calligraphy. We hope that the ten easy lessons in this book are the beginning of a life-long love affair with letters.

Questions and Answers

Q. *What can I do if there is a white or gray line through my thick downstrokes?*

A. This means you are putting too much pressure on your pen. You are pressing too hard on the nib and it is splitting so the ink cannot flow smoothly onto the paper. Put less pressure on the pen.

Q. *What if my thin lines are not thin enough?*

A. Either you are not holding the pen at the 45° angle (go back and practice zigzags), or you have too much ink on the pen. Clean the nib; when you dip the pen into the ink be sure to remove all the excess.

Q. *My writing is gray, not solid black. What can I do?*

A. You must shake the ink each time before using. If this does not change the density of your writing, let the ink stand open overnight so excess water can evaporate. Be sure it is in a safe place where it won't be knocked over. In addition, if you write more slowly and press slightly harder on the nib (but not enough to make it split), your writing will probably be blacker.

Q. *If I am left-handed, can I use a regular nib?*

A. Yes, but you will probably have to turn your wrist or paper a bit more than if you use a left oblique pen.

Q. *Can I ever vary the x-height from five nib widths?*

A. Yes. Changing the x-height will change the proportion between the counter and the strokes. For heavier or stronger letters, experiment with a slightly smaller x-height of 4½ nib widths. For lighter letters, try a slightly larger x-height of 5½ nib widths. Use this technique only to achieve a different effect, not as your standard Italic hand. Always measure and draw lines carefully.

Q. *Can I vary the x-height to make something stand out on a page?*

A. Yes. But be sure that the contrast is sufficient for the letter or word to stand out, rather than look like an error. You will need to experiment with x-height variations in order to make a good decision.

Q. *How can I make something stand out on the page?*

A. A contrast of size or color will emphasize a word or a line. Change letter size by changing nibs. The writing will stand out because it is smaller or larger. This is generally a better choice—and an easier task—than making letters of varying heights with the same nib (see question above).

Q. *Can I vary the length of the ascenders or descenders?*

A. Yes. Draw lines very carefully, making the ascender or descender space smaller or larger. Experiment with a standard 5-nib-width x-height space and an ascender or descender space of 4, 4½, or 5½ nib widths. You do not have to change both the ascender and descender lengths, but when you change one ascender you must make all the ascenders uniform, and the same for the descenders. Experiment for fun and variety, but do not make this your standard writing style.

Q. *Can I write without connecting any letters?*

A. Generally not. Italic letters like to touch each other. Your writing will have more grace and rhythm if you connect letters when possible.

Q. *When making corrections, can I write over the white paint?*

A. If you try to do this, the ink will probably spread over the white paint. See "Making Corrections" for advice on doing this effectively.

Appendix

The more tools and materials you know how to use, the more you can do with your calligraphy. Experiment with a wide range of tools and materials so that you know what to use for specific purposes and what works best for you. Most tools and materials are relatively inexpensive, so you can experiment with minimal investment.

In some cases, a highly recommended nib or paper may not give you the results you desire, but another tool may work better for you than it does for someone else. The more experienced you are and the more information you acquire, the better your judgment will be.

Other Dip Pens

There are many brands available; preference is largely personal. The following are recommended:

1. **Brause.** Brause nibs are firmer than Mitchell/Rexel and come in larger (wider) sizes. Measured in millimeters, the smallest Brause, ½mm, is approximately the same width as the Mitchell/Rexel No. 6, and the largest Brause, the 5mm, is considerably wider (and therefore makes a taller, bolder letter) than the largest Mitchell/Rexel nib, the No. 0. The reservoir is already attached to the Brause nib, on top of rather than under the nib.

 The Brause 2mm is approximately equal to the Mitchell/Rexel No. 1 that we are using in this manual. You can make your lines for Brause nibs using a paper ruler or you can use a metric ruler, multiplying the nib size by 5. Thus, for a 3mm nib, the space between your lines would be 1.5 cm (3mm x 5 = 15mm = 1.5 cm), which is easily measured.

 Brause nibs are a good choice, for beginners as well as for professionals. They are a little easier to handle than Mitchell/Rexel nibs because you can press a little harder on them without having them split. Some calligraphers also prefer them for working with gouache. The great advantage of Mitchell/Rexel, however, is that the fine lines (hairlines) are thinner, thus giving more elegant letterforms.

 Note that Brause nibs are cut slightly obliquely to the right. You will therefore have to adjust your hand to maintain the

45° pen angle.

 Left-hand Brause nibs are available, but usually need to be special-ordered (see Sources" in the Appendix)

2. **Speedball.** The large nibs in the C series (nibs No. C-0, C-1, and C-2) are better than the small sizes. They are not as sharp as the Mitchell/Rexel or Brause nibs, but are good for making large letters. Speedball nibs are widely distributed and left-hand Speedball nibs are relatively easy to find.

3. **Hiro/Tape.** These are similar to the Brause, and are also cut obliquely to the right and measured or numbered in millimeters. They are a little less stiff than the Brause, but not as flexible as the Mitchell/Rexel nibs. Like the Brause, the reservoirs are attached to the nib.

Broad-Edged Fountain Pens

This type of pen comes with an assortment of nibs. It is fun for practicing and easy to carry because the ink is neatly contained in a cartridge or ink well. Be sure to use fountain pen ink; Higgins Eternal will clog the pen. Take your fountain pen apart and clean it from time to time since it tends to clog easily, especially if it hasn't been used for a while.

The thin lines produced by fountain pens are not as fine as those made by dip pens. Fountain pens are not recommended for finished work. In addition, most fountain pen inks are not lightproof; your writing will fade and perhaps disappear over a relatively short period of time.

Shaeffer, Platignum and Pelikan all make inexpensive calligraphy fountain pens, some of which are available in sets (left-hand as well as right-hand).

Chisel-Edged Markers

Many brands are available in almost any stationery store. Try them before buying to be sure they haven't started to dry out. Some very good calligraphy markers are available from the mail-order calligraphy dealers listed at the end of this Appendix. Be advised, however, that most markers are not permanent; the colors will fade over time.

Inks

There are a number of decent inks available, and there seem to be new ones all the time. Read the descriptions in calligraphy supply catalogues (see "Sources," below) before you buy too many different inks, as some are better than others.

If you are using a fountain pen, be sure to use the ink (usually in cartridge form) recommended for the pen you are using. Pelikan 4001, a fountain pen ink that comes in bottles, is a good choice for both fountain and dip pens but is rather transparent and not lightproof; your writing will fade when exposed to direct light. It will, however, give you very nice hairlines.

Calligraphers often grind their own inks using traditional ink sticks and stones. Done properly, this can give you lovely ink, but it depends on the quality of the ink stick; there are many, many available. You may also want to try bottled Sumi (Japanese) ink, which will give you very black, shiny letters, but may also damage your nibs. If you try bottled Sumi, be sure to wash and wipe your nib often.

Again, it is generally better to avoid waterproof inks, although some are advertised for calligraphers. Gouache will give you better color results, but some colored inks are attractive. Be sure to clean your nibs often if you use waterproof ink.

Paper

Paper is available in pads or by the sheet. Most smooth, nonglossy papers are worth experimenting with to discover your personal preferences. The best way to choose a paper is to test it with your pen and ink. Does it absorb the ink? Does the pen skid? (If the answer is yes to either of these questions, the paper is probably not good for calligraphy.) Is the hairline fine? Often different nibs or inks will give you better (or worse) results, so take the time to test the paper carefully.

Following are some recommended papers for calligraphy:

Pads

1. **Layout paper.** These papers are sufficiently transparent to enable you to see your guidelines and will give you clean fine lines. Recommended are Canson Pro-Layout Marker, Bienfang Graphics 360, Borden & Riley Boris Marker Layout, and Borden & Riley Cotton Comp.
2. **Opaque bond paper.** These papers are heavier, but also have a smooth writing surface. Try Aquabee 666, Hammermill Bond, Strathmore Layout Bond, Paris Paper for Pens, and whatever copy machine papers you may have on hand, some of which will give you good results for practicing.
3. **Charcoal paper.** This comes in a range of colors. Try working on both sides; in some cases the back, which is smoother, will give you better results. Canson, Fabriano, and Strathmore all make good quality charcoal paper that is available in pads.
4. **Drawing paper.** Strathmore Drawing paper has a particularly nice surface for calligraphy and comes in a warm shade of white.

5. **Bristol board.** Sometimes calligraphers use medium- or vellum-surface bristol when a heavier-weight surface is required. It is necessary to draw lines on bristol, or to use a light box.

6. **Watercolor paper.** Hot press, or smooth surface, watercolor paper can be a great joy to write on. It is available in pads or by the sheet and tends to be expensive. Watercolor paper comes in at least two weights, 90-lb and 140-lb. The lighter-weight paper is less expensive and just as good for most purposes.

Paper by the Sheet

Calligraphy mail order suppliers and some art supply stores sell paper by the sheet, specifically for calligraphy. Some of the papers favored by calligraphers are machine-made and others are made by hand (and priced accordingly). Generally speaking, paper by the sheet is more expensive than paper in pads, but there is a much larger choice of surfaces, textures, and colors. It usually comes in large sheets which may be cut down as needed.

If they are available, try some of the following papers:

Arches Hot Press (watercolor)
Arches Text Laid
Basingwerk
Canson Ingres (lightweight charcoal paper, available in many colors)
Canson Mi Tientes (same as above, only heavier)
Fabriano Artistico Hot Press (watercolor)
Fabriano Ingres (similar to Canson Ingres)
Fabriano Tiziano (similar to Canson Mi Tientes)
Frankfurt
Gutenberg Laid
Nideggan
Saunders Waterford (watercolor)
Stonehenge
Strathmore Parchment

Keep samples of the papers that you like. Record on each sample the name, price, and sheet size and the store where you bought it.

Rulers

In addition to metal rulers, inexpensive plastic rulers can also be a boon for the calligrapher. Look for "Graph" or "C-Thru" rulers, which sit very flat on the page, enabling you to draw accurate lines. They are available in various lengths with both imperial and metric ruling.

There are boxes with a piece of frosted glass or plexiglas mounted over one or two fluorescent light bulbs. They can be found in many art supply stores.

Also available are plexiglas slant boards that can be positioned before or above fluorescent light fixtures, serving very well as light boxes. They are available by mail order from calligraphy suppliers and at some art supply shops.

When using a light box you may tape guidelines onto the glass, which will show through most light-colored papers, even fairly heavy or double-thick ones, such as envelopes. This arrangement can save you time and trouble by eliminating the need to draw and erase lines.

Waterproofing Your Work

There is no product currently available that will make your calligraphy 100 percent waterproof without doing damage to the artwork (or to the environment). In any case, waterproofing isn't necessary unless your work will be exposed to the elements or used where it may be carelessly handled.

If you are concerned that your calligraphy may be excessively handled or mishandled and perhaps smudged, you may want to spray it lightly with Krylon Crystal Clear or a similar acrylic coating. This will make it water-resistant rather than waterproof. Be sure to spray in a well-ventilated area and avoid inhaling the fumes.

Sources

New books and materials are continually being offered to calligraphers. Among the best sources for shopping and information are:

John Neal, Bookseller
1833 Spring Garden St.
Greensboro NC 27403

Phone: (800) 369-9598
E-mail: info@johnnealbooks.com
Web site: www.johnnealbooks.com

Paper & Ink Arts
3 North Second St.
Woodsboro MD 21798

Phone: (800) 736-7772
E-mail: paperinkarts@aol.com
Web site: www.paperinkarts.com

It is recommended that you contact both of these suppliers for a catalogue. Their catalogues contain up-to-date information (and recommendations) about calligraphy tools, materials and books.

Suggested Further Reading

There are many instructional and illustrative books on calligraphy and the Italic hand. The following are recommended:

Anderson, Donald M. *The Art of Written Forms*. New York: Dover Publications, Inc., 1992.

Arrighi, Ludovico degli. *The First Writing Book: An English Translation and Facsimile Text of Arrighi's Operina.* Translated by John H. Benson. New Haven: Yale University Press, 1966.

Brown, Michele P. and Patricia Lovett. *The Historical Source Book for Scribes*. Toronto: University of Toronto Press, 1999.

Camp, Ann. *Pen Lettering*. New York: Taplinger Publishing Co., 1958.

Child, Heather. *Calligraphy Today*. New York: Taplinger Publishing Co., 1979.

Child, Heather, ed. *The Calligrapher's Handbook*. New York: Taplinger Publishing Co., 1985.

Fairbank, Alfred. *A Book of Scripts*. London: Faber and Faber, Ltd., 1977.

Gourdie, Tom. *Italic Handwriting*. New York: Pentalic Corporation, 1979.

Haines, Susanne. *The Calligrapher's Project Book*. New York: HarperCollins, 1994.

Harris, David. *The Art of Calligraphy*. New York: DK Publishing, 1995.

Jackson, Donald. *The Story of Writing*. New York: Taplinger Publishing Co., 1981.

Johnston, Edward. *Writing & Illuminating & Lettering*. New York: Dover Publications, 1995.

Knight, Stan. *Historical Scripts*. New Castle, Delaware: Oak Knoll Press, 1998.

Miner, Dorothy E., Victor I. Carlson, and P. W. Filby. *Two Thousand Years of Calligraphy*. New York: Taplinger Publishing Co., 1980.

Ogg, Oscar, ed. *Three Classics of Italian Calligraphy*. New York: Dover Publications, Inc., 1953.

Pearce, Charles. *The Little Manual of Calligraphy*. New York: Taplinger Publishing Co., 1981.

Reynolds, Lloyd J. *Italic Calligraphy & Handwriting Exercises*. New York: Pentalic Corporation, 1969.